STYLES IN PAINTING
ABSTRACT PAINTING

BARRON'S

Abstract Painting

Designed and produced by
Parramon Paidotribo

Editorial Director: María Fernanda Canal
Editor: Mari Carmen Ramos
Text: Gabriel Martín Roig

Exercises:
Josep Asunción, Mireia Cifuentes,
Gemma Guasch, Gabriel Martín,
Esther Olivé de Puig, Isabel Pons, and
Gloria Valls
Collection Design: Toni Inglés
Photography: Estudi Nos & Soto
Layout: Estudi Toni Inglés
Prepress: iscriptat
Production: Sagrafic, S.L.

First Edition
English Translation: Michael Brunelle and
Beatriz Cortabarria

All inquires should be addressed to:
Barron's Educational Series, Inc.
250 Wireless Boulevard
Hauppauge, New York 11788
www.barronseduc.com

ISBN: 978-1-4380-0682-6
Library of Congress Control Number:
2014948370

Printed in China
9 8 7 6 5 4 3 2 1

STYLES IN PAINTING
ABSTRACT PAINTING

How to Access the Multimedia Content

You can access the multimedia content through augmented reality or by registering on the web page.

■ Through Augmented Reality

1 Download the free AR application at:
http://www.books2ar.com/abs/app

Or through:

2 Use the app to scan the pages where you see these icons:

■ Through the Web Page

Register on the web page for free, **www.books2ar.com/abs** using this code:

The app requires an Internet connection to access the multimedia content.

At the beginning of each exercise an icon indicates the multimedia content that is available.

ANOTHER STEP-BY-STEP

PRELIMINARY NOTES AND SKETCHES

GALLERY

MORE IMAGES OF THE EXERCISE

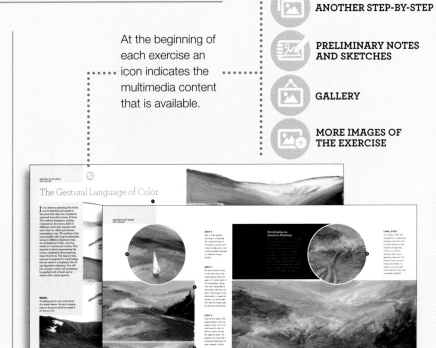

To see the multimedia content, scan the page where you see the icon and a brief text.

Augmented reality in three simple steps:

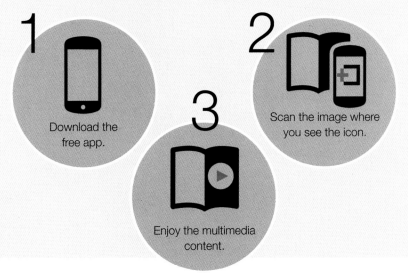

1 Download the free app.

2 Scan the image where you see the icon.

3 Enjoy the multimedia content.

Contents

Breaking with the Figure

Traditionally, the great painters used paint to attempt to imitate, copy, and capture nature, the landscape, cities, people, objects, flowers, and the sea in order to retain part of their beauty. They had the idea that the more the painting resembled the subject, the more merit it had. A few centuries ago, art was more stable and linear, as the artist's guilds and the academies of painting exercised control over the field. For example, they blocked dissidence and imposed norms on the artists, in effect acting as centers for artisans that attempted to preserve and perpetuate the transmission of the traditional techniques of painting. Their guidelines were not opposed and were accepted as being the most logical, most natural, and best way of doing things.

This attitude was defied for the first time in the 20th century when some painters began breaking the rules and developing what today is known as abstract art. This new form of art departs from realism in its representation of imagery to the point that the created paintings made no reference to nature and did not follow any rules. This new concept had such an impact on artists that in just a few decades abstract painting became one of the most important styles of the 20th century, one that created the greatest repercussions in the history of art and continues to be an important movement today.

The creative enthusiasm of abstract artists has not and is not shared by the general public. For many, abstract painting seems a mockery; they feel that it is a fraud or a scam. Those who are unable to appreciate or understand abstract art wonder why artists have abandoned the conventional techniques of painting, maintaining a mistaken belief that many painters are trying to hide their lack of ability or skill by making abstract art. Nevertheless, the important avant garde artists of the 20th century were not novices by any means, and their early periods were characterized by their mastery of figurative painting. They had a deep understanding of the trade, and they learned and followed the most traditional painting trends before developing their personal styles.

Nowadays, artists do not observe the mission of preserving and transmitting the traditional techniques, they are not subject to academic norms, not even in the representation of the figure. Thanks to abstraction, they enjoy complete freedom of expression in their forms, proportions, spaces, and perspectives, thus offering new ways of enjoying and appreciating painting. Abstract work has become the purest expression of the subjectivity and interior world of the artist. By this means, they directly transmit feelings through forms, colors, light and shadow, and composition, creating a plastic world apart from our reality, one that is capable of evoking sensations and feelings in us.

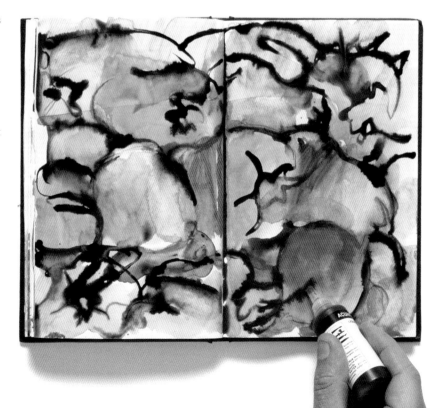

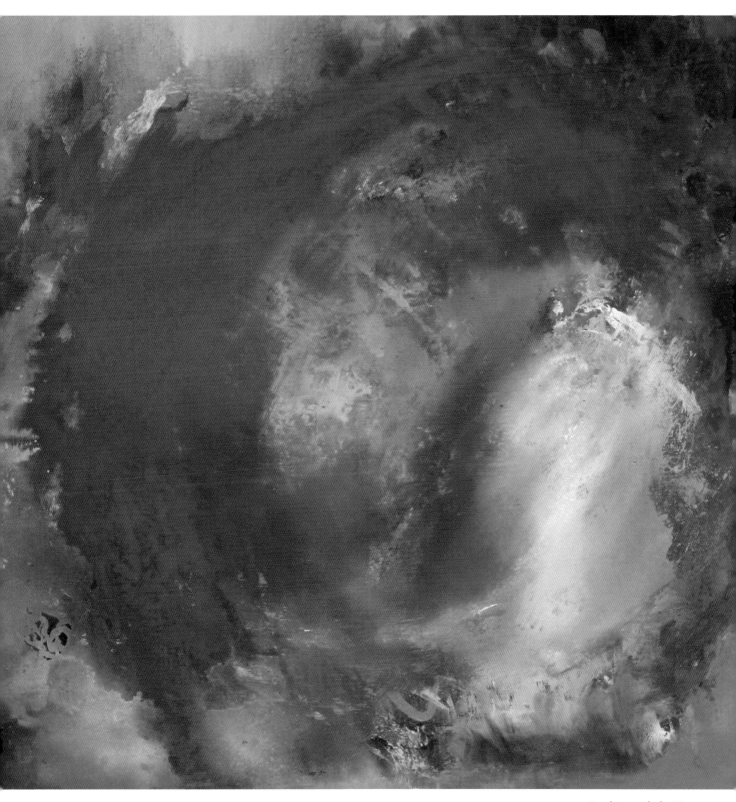

A Half Century of Abstraction (1910–1960)

The arrival of Impressionism and the new pictorial concepts, the crisis of spiritual and material values at the end of the 19th century, and the birth of photography without a doubt encouraged the development of abstract art. As a consequence, artists began expressing themselves in new ways since they did not feel the need to reflect the reality of what they saw, exactly as they saw it, which was now the task of photography. Many creative people turned inward, centering on themselves and their interior lives, so they could find a way to translate the new reality with painted images. In this chapter we offer a short excursion through a half century of abstraction so you can better understand its origins.

The Beginning

The beginning of abstract art is extremely difficult to pinpoint. It did not appear spontaneously but rather as the result of the evolution of the first appearances of semi-abstraction that were being produced at the end of the 19th century by the Symbolist and Postimpressionist painters like Paul Sérusier, James Ensor, and Paul Cézanne, among others. In *The Talisman* (1888), Sérusier made use of some of the basic principles of this new style of painting: complete synthesis of the forms, a tendency toward geometric shapes, and a simplification of the applications of color, all of which push this work to the edge of being recognizable, between the figurative and abstraction. The Belgian artist James Ensor in *The Expulsion of the Fallen Angel* (1889) recreated the combat between celestial and demonic forces with quick and dynamic gestural brushstrokes that broke down the forms, converting the work into a neurosis of crazed strokes that look like the creations

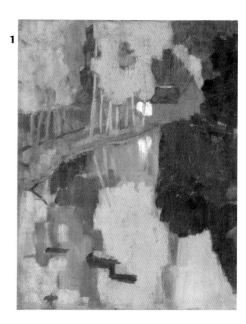

of Abstract Expressionism. For his part, Paul Cézanne made very interesting paintings throughout his lifetime. For example, those paintings made of the mountain Sainte-Victoire (1888–1904) materialized with overlaid units of structured colors that form fluid reflections that dance in the eyes of the viewer. In his final works, the shapes of the mountain and the landscape nearly disappear behind a prism of strokes of color. Despite the interesting move toward abstraction by many artists in the 19th century, none of them can be considered truly abstract since they never quite departed completely from the subject matter in their work. It was never their objective, and they always maintained a minimal attachment to the figurative.

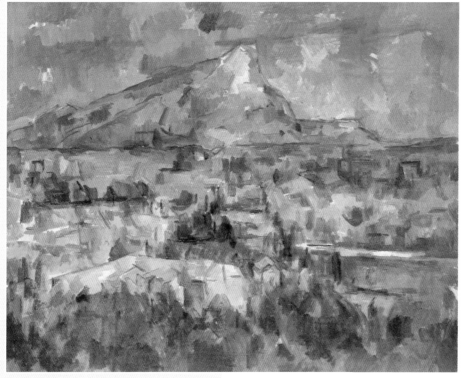

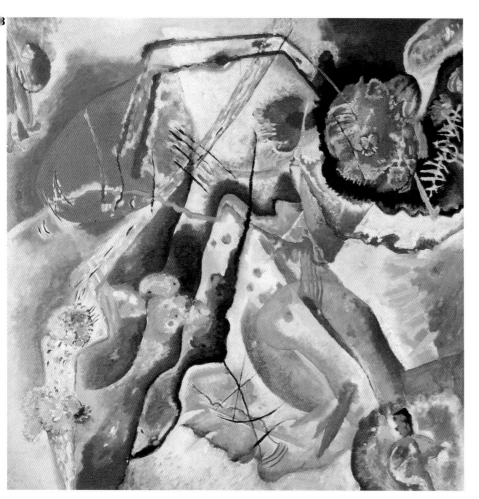

The First Abstract Works: Kandinsky and Klee

Just like the Postimpressionists, in the first quarter of the 20th century the German Expressionist painters belonging to the groups known as *Der Blaue Reiter* (the blue rider) and *Die Brücke* (the bridge) attempted a renovation of art, a search for fundamental forms through color. One of the most famous members was the Russian Vassily Kandinsky, who decided to orient his painting toward a thoughtful purification. He stopped imitating nature and other real models, and through a process of purifying and simplifying lines and colors, he created in his studio a small watercolor that produced in him a profound emotion. It can be considered the first abstract painting since it was specifically created with this intention. Lacking any subject and not derived from any visual reference, it was only about harmony of lines and areas of color. Another artist, Paul Klee, who was associated with the German Expressionists, also developed imagery where real forms little by little were reduced to primary symbols like the circle, the square, the triangle, and organic shapes. This simplification of form took him close to abstraction, both in the works of his first period, which are catalogued as mystical, and in those he created during his years as a professor in the Bauhaus school. A good example of this is his painting *Harmony of Squares in Red, Yellow, Blue, White, and Black* (1923). Thanks to these two pioneers, abstract painting was finally freed from any association with reality.

1 Paul Sérusier, *El talismán*, 1888. Musée d'Orsay, Paris, France.

2 Paul Cézanne, *La montaña Sainte-Victoire vista desde Lauves*, 1902-1904. Philadelphia Museum of Art, Philadelphia, USA.

3 Vassily Kandinsky, *Pintura con mancha roja*, 1914. Musée National d'Art Moderne Georges Pompidou, Paris, France.

Geometric Abstraction

Even though the first glimmers of abstraction can be considered derivations of Fauvism and Expressionism, a much more geometric abstraction was developed in Russia after Kasimir Malevich published his Manifesto of Suprematism in 1915, which promoted pure sensation through the restricted use of color and simple geometric shapes. His theories were a source of inspiration for an entire generation of artists led by Liubov Popova, El Lissitzky, and Aleksandr Rodchenko, who followed the same line. This yearning for the purification of forms also was manifested in Holland with the creation of the group

De Stijl (1917), which offered Neoplasticism as an alternative, a painting style that emphasized the two-dimensionality of the plane, basically rectangles and squares, and used only primary colors: red, yellow, blue, black, and white. White was used as a neutral background, and black was used to highlight outlines and interweave straight lines. This way they defended clear geometric order, the purification of forms, in an attempt to arrive at the most basic and elementary form. Piet Mondrian and Theo van Doesburg are the most well known of this group.

2

1 Piet Mondrian, *Composition with Red, Yellow, and Blue*, 1937–1942. Tate Gallery, London, England.

2 Olga Vladimirovna Rozanova, *Flight of an Aeroplane*, 1916. Art Museum of Samara, Samara, Russia.

1

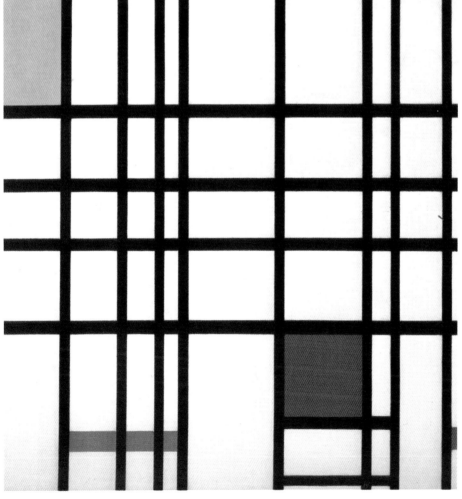

Abstract Expressionism and Informalism

In the middle of the 20th century, most of the important avant garde painters had abandoned figurative work and begun to explore new styles within abstraction. The presence of important artists of the European vanguard in New York, after the outbreak of World War II, encouraged the emergence of Abstract Expressionism beginning in the 1940s, a current that joined Abstraction and Automatism. Abstract Expressionism was characterized by two movements: one gestural, also known as Action Painting, which was very passionate and based on gestures made with the brush, and another that focused on the treatment of surfaces with color, or Color Field Painting, which combined bands of color in large format works. In the first group were Jackson Pollock, Willem de Kooning, Franz Kline, and Robert Motherwell; Mark Rothko, Clifford

Still, and Barnett Newman were in the second. In Europe, Informalism, a tendency concurrent with Abstract Expressionism, was developing. It has a much more tragic character, a much grayer range of colors, and great interest in the use of materials and the creation of textures on the canvas. This causes the painting surface to function as a wall, where you can see scratches, flaking and chipping, incisions, and other marks. Among this group are the works of Jean Dubuffet, where monochromatic masses rise and fold, making the surface of the canvas look like sedimentary landforms. The interest in incorporating new materials and textures allowed these artists to avoid figurative work. Antoni Tápies, in fact, almost completely erases the limits between the canvas and a simple wall, completing them with sgrafitto, incisions, wide brushstrokes, and objects incorporated into the canvas.

3 Antoni Tàpies, *Painting*, 1955. Museo de Arte Reina Sofía, Madrid, Spain.

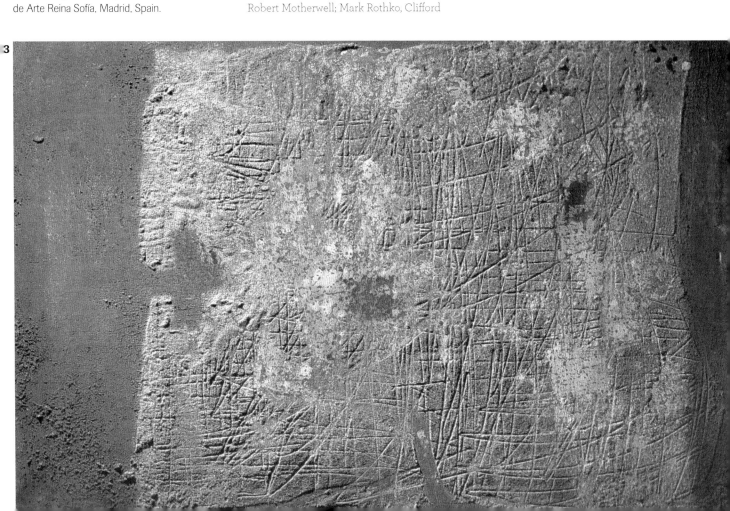

DECONSTRUCTING REALITY

Abstract art does not just appear from nowhere; on the contrary, it is the result of a careful process of deconstructing the forms in nature. The abstract interpretation of an object or a concept can be slight, partial, or complete, since abstraction is not always radical and can often be rather gradual. Artists who wish to become immersed in the difficult field of abstract interpretation should first learn to transform real models into synthetic recreations, where the colors and shapes are clearly altered while preserving some indications that make the model recognizable. Therefore, abstract art should not necessarily be seen as a concept that is opposed to figurative art, but as an exercise where the artist takes a few liberties, like mixing colors without any restrictions, or creating forms that freely relate to each other and are freed from having to look like the real model. In this first section, we explain the basic strategies that artists can use for transforming a real model into partial and complete abstractions.

Synthesizing Is Abstraction

The first step in painting an abstract is learning to synthesize, reducing the visual information into simpler units, working the areas in a general way without worrying about the details. This is a purifying process, where the colors are simplified, and, almost without trying, the reality is transformed and captured in a representation that begins to look abstract. Begin by synthesizing each zone of the subject in an area of color, more or less flat and uniform. In this way, the entirety of the subject is fragmented into chromatic units or smaller forms.

Synthesis Through Subjective Reduction

The artist practices subjective reduction of reality so that the forms are synthesized as areas of color based on his or her imagination and sensibilities. To practice this process, you must follow the guidelines: The most complex forms must be transformed into simple symbols like ovals and natural organic shapes. The choice of colors should be free, and the colors can be blended and gradated with each other for no apparent reason. There should be an absence of perspective and other conventionalisms that create a sense of space. Finally, you can incorporate apparently random colors and graphics that relate to an interest or personal taste. Here are four models of synthesis based on the same model.

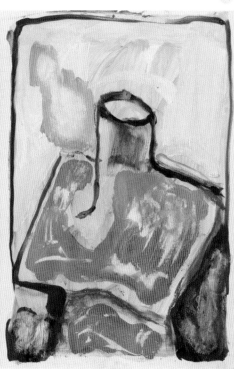

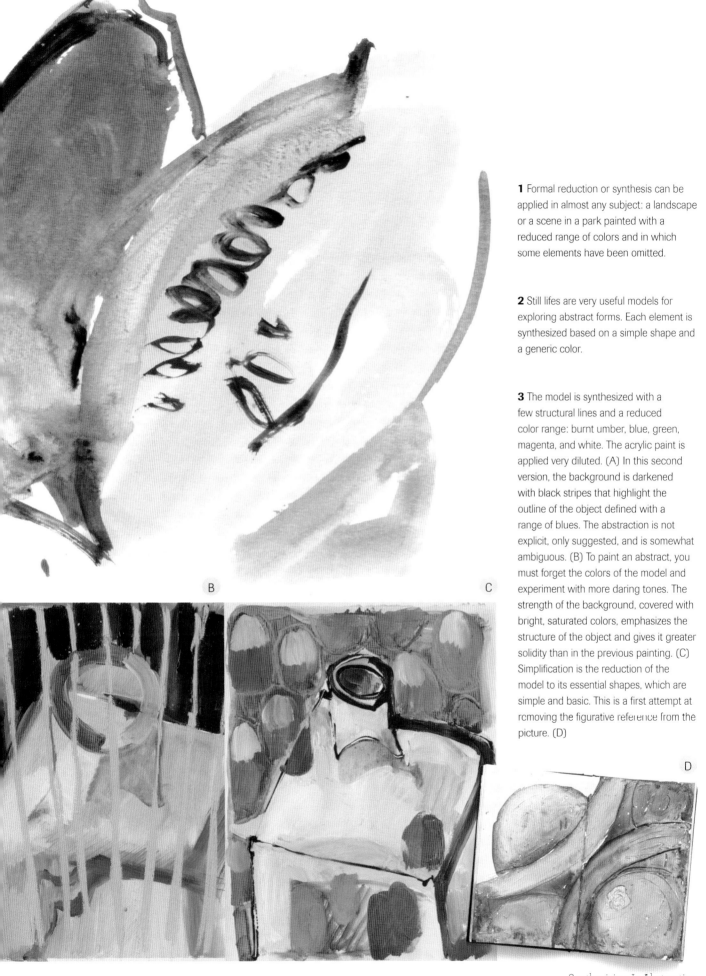

1 Formal reduction or synthesis can be applied in almost any subject: a landscape or a scene in a park painted with a reduced range of colors and in which some elements have been omitted.

2 Still lifes are very useful models for exploring abstract forms. Each element is synthesized based on a simple shape and a generic color.

3 The model is synthesized with a few structural lines and a reduced color range: burnt umber, blue, green, magenta, and white. The acrylic paint is applied very diluted. (A) In this second version, the background is darkened with black stripes that highlight the outline of the object defined with a range of blues. The abstraction is not explicit, only suggested, and is somewhat ambiguous. (B) To paint an abstract, you must forget the colors of the model and experiment with more daring tones. The strength of the background, covered with bright, saturated colors, emphasizes the structure of the object and gives it greater solidity than in the previous painting. (C) Simplification is the reduction of the model to its essential shapes, which are simple and basic. This is a first attempt at removing the figurative reference from the picture. (D)

B

C

D

Deconstructing the Object

Simplification and the use of geometric shapes are very useful tools for the artist when transforming the real model into an abstract representation. It is a matter of finding the essence.

Even though it is true that purely abstract paintings usually seem detached from the real world, they almost always have as a point of reference something that the artist has seen or experienced. In the following example, we show you how to paint a derivation, that is, how an abstraction is created from a rational process of creating form. You begin with a synthesis of the model, with very simplified and well-defined elements to create a derivation: the essence of the original image is deconstructed until it becomes a completely abstract representation.

Transforming and Flipping the Image

In this section, we offer another example to help clarify, another way of transforming a real model into an abstract work. The starting point is a figurative representation of some stone columns drawn in charcoal. Then, these supports were painted with watercolor, crimson in the areas of shadow and light blue in the illuminated parts. To move the representation away from the real model, we apply a mirror effect, moving the curvature of the arches above to the lower part of the painting. Some more color is added, and then the painting is turned to a vertical format to completely eliminate any figurative reference.

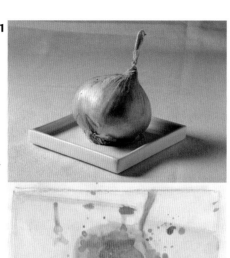

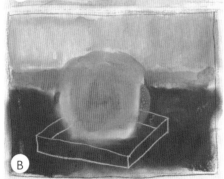

1 The object is exploded and separated into small chromatic units or splotches that cover the scene. (A)

Finally, a very stylized approach is taken by adding linear strokes with a strong graphic feeling. (B)

2 Here we use the squares on the tablecloth as a reference for creating a background of colors. The objects are barely defined by a few warm strokes of orange and red. (A)

In this other version, we synthesize the color with very diluted paint. Then, a few linear shapes are added with black and sepia inks. The

ink drawing is very incomplete, it is just barely suggested. (B)

A final version painted with washes of acrylic paint that was only partially allowed to dry and then wiped with a damp sponge to remove part of the layer of paint. The result is a ghostly image, like a print of the object. (C)

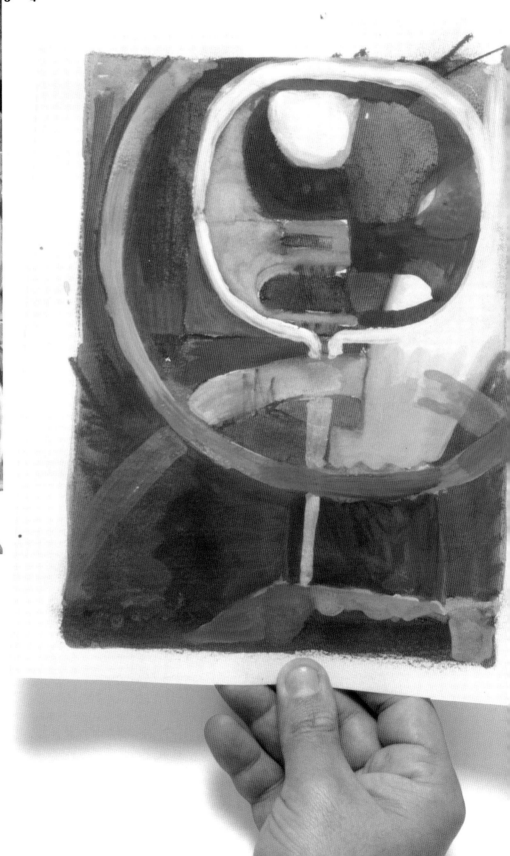

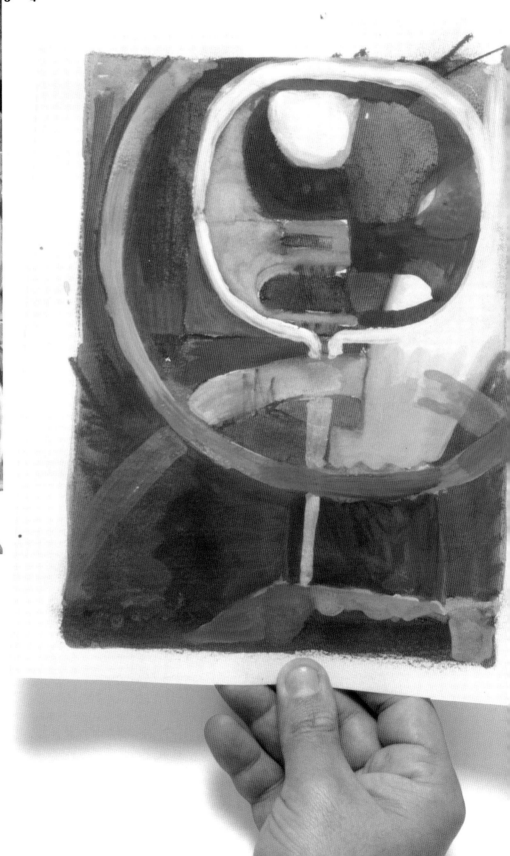

3 Make a figurative drawing of the model with charcoal and paint it with imaginative colors. Project the curve of the arches to look like the effect of a reflection in the lower part of the painting. (A) Finish the model with additional colors that harmonize with the previous ones. (B)

4 To finish, turn the model to a horizontal position so the viewer will not be able to identify any references from the original model.

Seduced by Washes and Areas of Color

Another way of approaching abstraction is to simply emphasize the chromatic aspects, the form, and the structure, while experimenting with washes, puddles, and stains as the only medium. It is a subconscious process where uncontrolled elements, which are related to chance, mainly predominate. It is not a matter of being inspired by a real image and synthesizing its basic forms, but rather allowing yourself to be carried away by the pleasure of experimenting with color and shapes that are more or less random, created by the water that is trapped in the texture of the paper. The only thing that gives this approach validity is the process of working with the paint. Become seduced by the beauty of the shapes and the combinations of diluted paint without any figurative reference, by art for art's sake, and by the simple seduction of color.

1 This is just a matter of playing with paint combined with a few strokes of oil pastel with the goal of showing its strength and expressive power, without trying to imitate models or the shapes of real objects.

2 You must play randomly with the washes, flooding the paint on the support so it blends and mixes to make organic shapes.

3 Color washes add fluidity and transparency to the work. If you want to dribble the paint around, you just have to raise a side of the support and the puddle of paint will flow across the surface.

1

Let the Washes Flow

To experience this method, you must abandon vertical painting and the easel and lay the support flat on a table or even the floor.

Then dilute acrylic paint or watercolor with a large amount of water and spread it with a brush, a spoon, or pour it directly from a bottle or can. Each layer of paint should flow freely and dry completely before you apply another layer over it. Thus, the abstraction is expressed through the organic shapes created by the diluted paint and the colors, creating compositions unrelated to reality, and that results in an independent artistic expression that can evoke feelings and sensations.

3

2

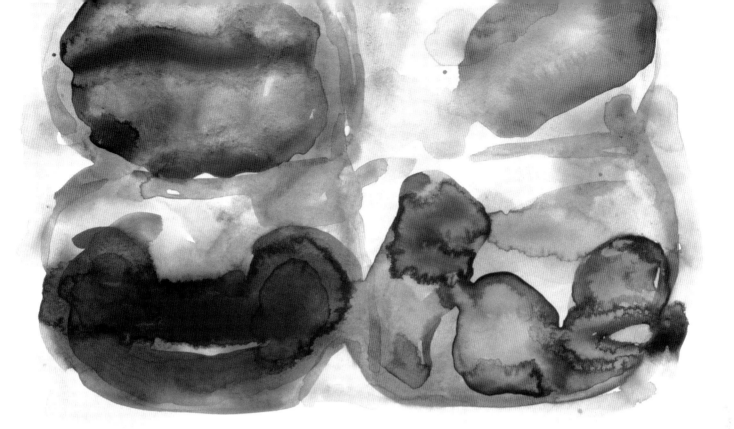

5

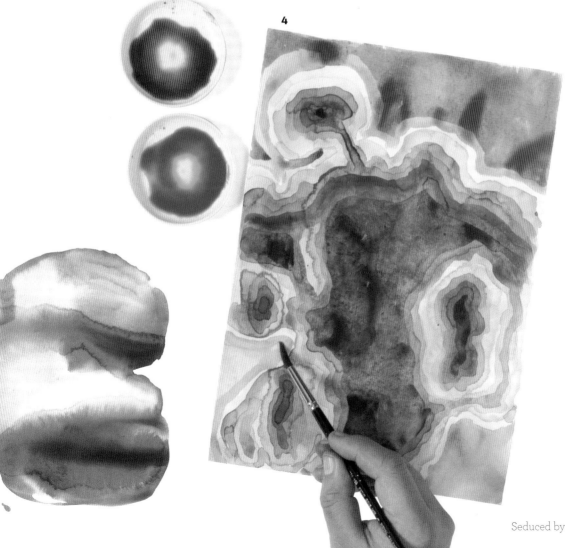

4

4 You must try different combinations of shapes and colors, playing with overlaying and glazing and with bands of colors to create the feeling of movement and fluidity.

5 Each application of paint should be added after the previous one has completely dried. The working process is slow since you must wait for each layer of paint to dry.

Seduced by Washes and Areas of Color

Geometric Fragmentation

Geometric shapes are themselves very useful tools for turning a real model into an abstract representation. However, geometrically deconstructing a model is a more rigid exercise than other representations based on areas of mixed colors and color washes because you are working with stricter guidelines where the shapes are subject to mathematical rigor and have a strong structure. A good start consists of making simple drawings with a graphite pencil on cartridge paper, simplifying the basic forms using geometry, with a light line that can be completed with shading in three or four different tones. These exercises are an opportunity for expressing the smoothness and gentleness of gradations made with graphite.

1

2

3

1 You can begin with a couple of drawings done in pencil. Break up the model into simple geometric shapes that accumulate to form a structure that is shaded with gradations.

2 Another version with volumetric forms with a somewhat cylindrical tendency. You must treat the shading with care and avoid stiffness. In these cases adding details will be overdoing it.

3 You can choose a highly synthesized geometric approach in which the model is barely indicated with a few flat shapes and strengthened with dark lines.

4 Geometric interpretations also allow you to create abstractions with objects that are still identifiable. Many variations can be created using this kind of fragmentation.

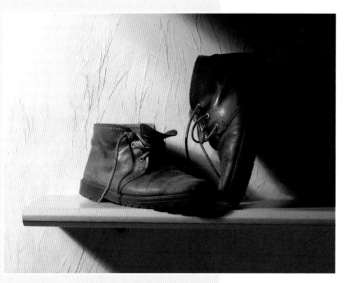

4

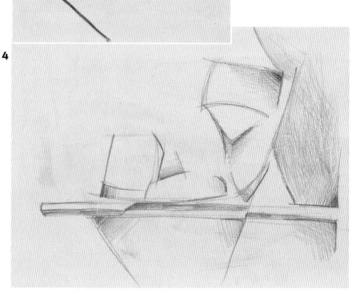

The Geometric Process with Colors

Shape and color are vitally important in geometric abstraction, which is created by reducing each of them to their essence. Here are some guidelines for how to use color to make a geometric composition. First, do not limit yourself to using only primary colors (red, blue, and yellow). You must mix them in the same way that you would for a figurative painting to create truly accurate contrasts and harmony. It is not a good idea to apply them flat, you can make gradations with them and even create transparencies. Repeating symmetrical patterns is not advisable, and repetition and regular arrangements of color should not be used. It is best to use asymmetrical schemes and on certain occasions surprise us with strong contrasts between the different elements in the painting.

5 This geometric synthesis was made with watercolor washes. It stands out because of its simplicity and lack of artifice. The background was suggested by the colors of the actual objects.

6 The two boots in the center, represented by rectangular shapes, are the axis for the structure of lines that rhythmically extend across the surface of the paper.

7 This time we chose to reproduce the same model with flat geometric planes. The figurative reference almost disappears completely because of the structure and the tension created by the colors.

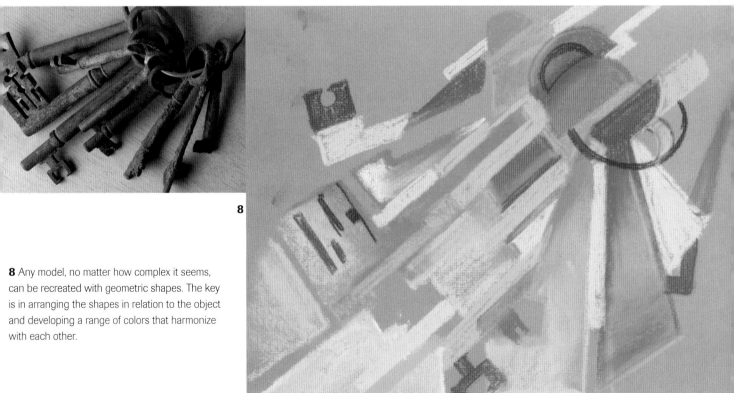

8 Any model, no matter how complex it seems, can be recreated with geometric shapes. The key is in arranging the shapes in relation to the object and developing a range of colors that harmonize with each other.

Feeling and Color

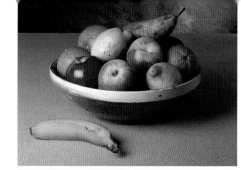

In abstraction, color is not dependent on the model but contains its own essence, which converts it into an independent element and a unifying force in the painting. It is not true that any combination of colors is acceptable in abstract art. It is better to work with reduced ranges of harmonious colors than to develop wide ranges of mixtures and shades that flood the painting with color. When choosing colors, you must rely on your instinct, on your personal feelings; however, it is best to avoid those that seem most obvious. If you are painting a lemon it is not necessary to use yellow. In the same way, green does not have to be present in a landscape.

1 During the creative process, the artist can experiment with a wide range of colors. If they are saturated, they communicate a sense of warmth and liveliness. The color of the support also can be an active part of the composition. (A)

You must avoid the obvious; the colors you choose do not have to be related to those of the real model. The choice is very personal and should depend on what you wish to communicate. (B)

2 This color sketch suggests the deconstruction of the model based on color, transgressing the shapes and edges of the objects and breaking down the outlines in a vigorous scattering of colors that are much more expressive and free.

1

A

B

2

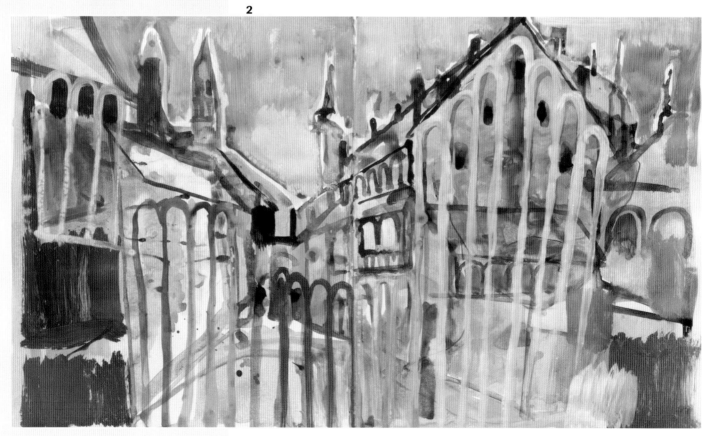

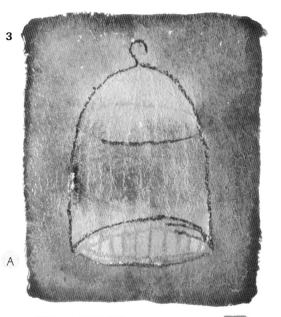

A

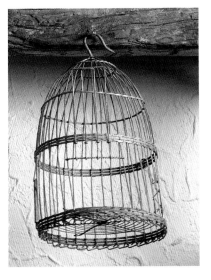

A Repeated Object with Simple Melodic Ranges

You can practice abstract deconstruction based on harmonizing colors by placing a very simple object on a table as a model and then preparing several supports with different colored backgrounds. The work should be done with large brushes so the brushstrokes will be solid and structural. Paint several versions of the object with simple ranges of just two or three melodic or harmonious colors. The different applications of paint can be blended with each other so they do not look too flat. The result will be a group of semiabstract works showing a wide range of solutions based on a single original object.

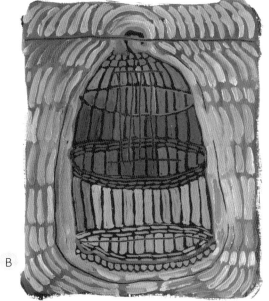

B

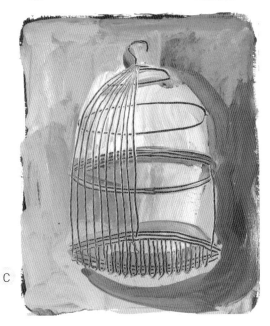

C

3 The first version was watercolor-painted on wet paper where the greens of the object blend with the yellows of the background. The few lines that can be seen were drawn with wax crayons. (A)

This example was painted with oils. The lines of the cage were created by allowing the colored primer on the support to show through. This technique is used by many artists because it creates strong chromatic vibrations. (B)

This exercise is similar to the previous one, although the yellow paint is denser against the already dry red background. The drawing of the object was created with sgrafitto, scratching the surface with the tip of a spatula.

The Value of Line in Abstraction

After you have learned the basics of synthesizing and abstracting a model with a rational study of its forms and colors, it is time to work with line, which can also become the protagonist of an abstract painting. It is usually used to partially describe some outlines of the actual model and to create a rhythmic series that can be very striking graphically. It can be done with a brush, with sgrafitto, and with simple drawing tools, but it is the gestural component of the line that is important. Not just any line is of value; it must be decisive and definite and create a strong counterpoint to the rest of the components of the painting.

1 The droppers in ink bottles can be used as very effective drawing tools, which can be used to make very strong lines.

2 Using lines can also become a key process for the creative expression of the artist, as a perfect complement that defines paintings done solely with applications of color.

Linear Work on a Colored Background

Lines suggest the outlines of shapes and can be converted into the ideal complement for adding greater graphic variety to a painting made by superimposing areas of color. When applied over a base of colors, it can suggest materials and forms beyond any supposed obligation to imitate the model. You just have to be careful to avoid any descriptive and minute details to achieve a more gestural and free expression. An interesting exercise is drawing calligraphic lines over a background painted with watercolor and going over them with color inks. Note the results next to this paragraph.

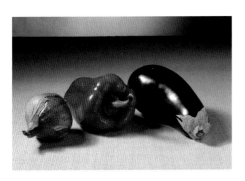

3 Lines can be drawn directly with the dropper from the bottle of ink and should result from quick motions of the forearm made without taking time to think.

4 The best way of working is to make different versions of the same model. The lines should be flowing and not show any concern for the proportions of the objects.

5 First cover the paper with watercolor washes of different colors. When they have dried, partially draw some edges of the model with the dropper from an ink bottle.

6 The artist should draw with gestural motions, without thought or corrections. This will create a nearly calligraphic line that is strong, electric, and able to communicate great dynamic energy.

3

4

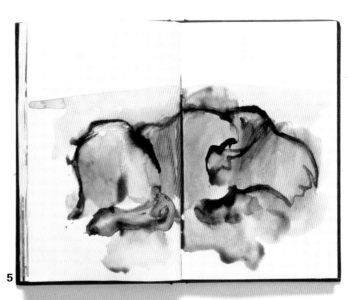

5

6

STRATEGIES FOR ABSTRACTING THE FORM

Seeing abstraction as a style or group of styles is too limited as an attitude. Abstraction can be understood as an investigative process, an exploration. It implies the need to analyze the model and to measure, alter, adjust, and balance its different parts. In this first section, you will create some forms of abstraction that are hybrids and flexible, based on purifying or distilling, synthesizing, and transforming the shapes of the real model. We offer several conveniently selected exercises to promote and facilitate the development of your ability to abstract and of your abstract reasoning, mechanisms that will help you use a wider range of visual techniques and to form an esthetic criteria. The technical and intellectual capacity to abstract and simplify the basic units of an image to the point that the original figurative reference is hardly recognizable is very necessary for artists today, although unfortunately it is barely developed.

STRATEGIES FOR
ABSTRACTING THE FORM

Geometry as a Model for What Is Essential

Many artists are accustomed to painting objects, their surroundings, and nearby landscapes. These are subjects that they are used to seeing but not analyzing and carefully observing so as to understand their structure, composition, form, and colors, going beyond their superficial appearance. To help develop this ability to analyze, we offer a very simple exercise, "translating" a model with simple geometric shapes and flat colors. In other words, planning a first attempt at abstraction through the use of purely geometric units, as if they were pieces of a puzzle that fit into each other like gears, diluting the perception of the object to create a solidly dynamic and structured composition.
The approach makes use of a combination of acrylic paint (in the first steps) and oils (in the finishes).

STEP 1
There is no need for a preliminary drawing. The first applications of acrylic paint should attempt to place the simple geometric shapes, more or less in order, while maintaining the diagonal that describes the inclined roof.

STEP 2
You must try to distance yourself from that which is purely real and allow yourself to be carried away by the emotional content. This means forgetting about the browns and blues in the model and developing a far different range of colors with flat strokes that celebrate the two-dimensionality of the place instead of representing the three-dimensional reality.

MODEL
The reference photograph that this exercise is based on is a very tightly framed image of the upper part of a building.

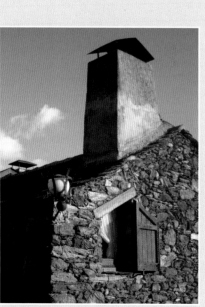

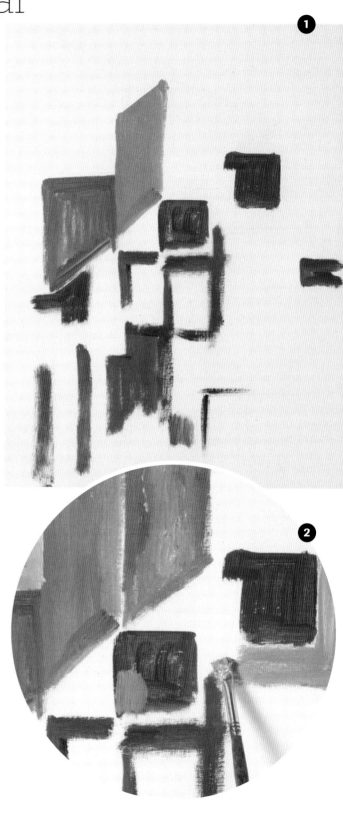

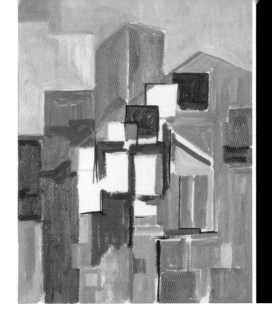

Filling in the Spaces

All of the spaces on the support should be filled in like a mosaic. The texture of the stone wall is represented with geometric shapes that are smaller, bunched together in the center of the composition, whereas the sky is painted with larger areas of color that do not contrast as much with each other. All of the pieces should fit together like gears. You should take the attitude that without the photographic reference, few people would be able to identify the figurative element that inspired this work.

STEP 3

Cover the space in the sky with different tones of violet and blend them with each other. On the wall of the house, the blocks of color should be smaller and contrast more. Geometric abstraction, reason, logic, and calculation should all be in perfect balance, with no errors in shape or color.

STEP 4

Despite the overlaid rectangular blocks, there is still a connection to the form of the original model. The chromatic range used here has limited the contrasts between the violets and oranges, and the structure is reinforced with a few broken linear shapes that add graphic variety to the work.

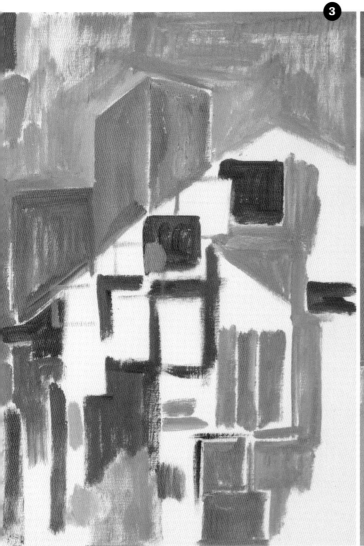

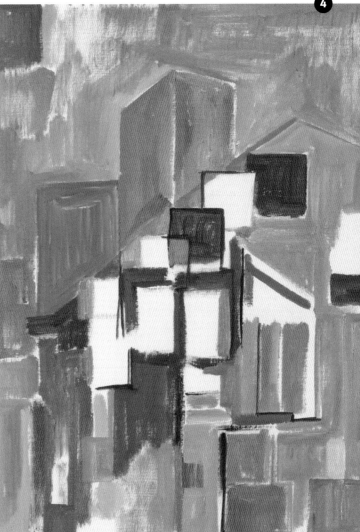

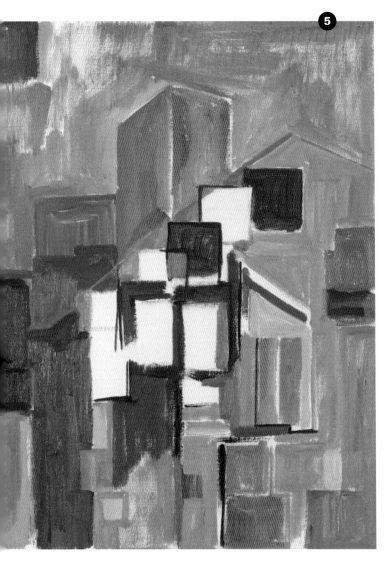

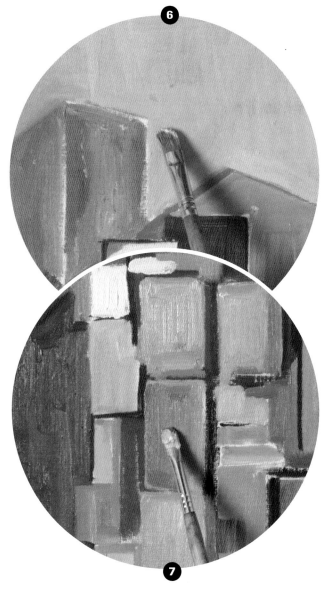

STEP 5

Allow the acrylic paint to dry, and from now on work with oils. They will create a denser layer of paint and add a sheen to the surface.

Apply the grayer tones, partially covering the layers of paint underneath.

STEP 6

Whiten the sky with new applications of gray colors to reduce the saturation in this area.

The layer of paint should be applied thinly, like a glaze, so that the underlying violets show through and have an effect on the final tones.

STEP 7

Complete the rectangular shapes in the center of the painting with cadmium yellow mixed with a bit of orange and a lot of white. The paint is thick, and the marks left by the brush will be clearly visible. The whites are not those of the support, they are a thick layer of titanium white.

FINAL STATE

After the painting is finished, you will see that the geometric technique is valid for carrying out the observation, analysis, and composition of any real model. It demonstrates that any artist can develop the ability to make abstracts based on pure geometric shapes.

See another exercise based on a geometric scheme.

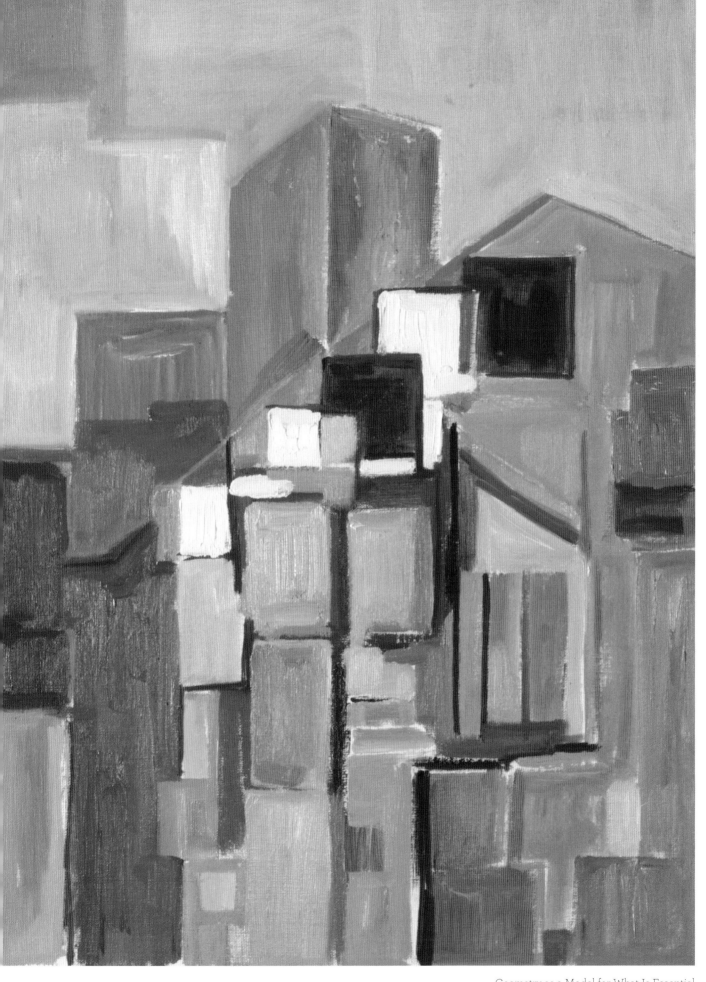

Geometry as a Model for What Is Essential

Breaking Up the Form

Abstraction results from a process of simplification carried to the extreme. Not only are the colors synthesized, but the forms are as well, although the final perception depends a lot on the way that the artist applies and manipulates the paint on the support. Unlike the previous exercise, here the chromatic structures do not follow the geometric shapes and areas of flat color; rather, each stroke and application of paint has fainter edges that blend, mix, and even gradate with the other nearby colors. In this process of synthesis, the way you apply the paint and the effects you create with the action of the brush become most important: painting for painting's sake. The work is not valued for what it imitates but for the way it is synthesized in very few strokes of oil pastels and oil paint.

STEP 1

A preliminary drawing made with a graphite pencil is required to indicate the proportions of the cat. Use light lines and mainly focus on describing its outline without worrying about details.

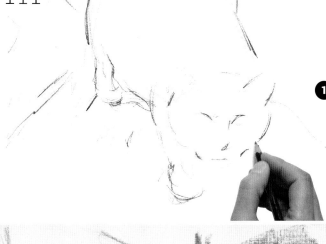

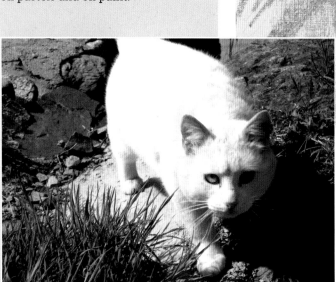

MODEL
The point of departure for this exercise in semi-abstraction and the synthesis of color is a cat stealthily creeping through the grass.

STEP 2

The first application of color will be made with sticks of oil pastel, dragging them sideways to quickly cover the main areas. The colors, which are just approximated, are inspired by the local colors seen in the photograph.

STEP 3

Add some more lines with the oil pastels; this time use the points to make parallel lines in an attempt to better define the contrast existing between the background and the cat. Use cyan blue to represent the shading on the cat's white fur.

STEP 4

This medium is oil-based, so you can dilute the lines with a brush dipped in essence of turpentine. The shading thus becomes areas of transparent color that looks somewhat like watercolor.

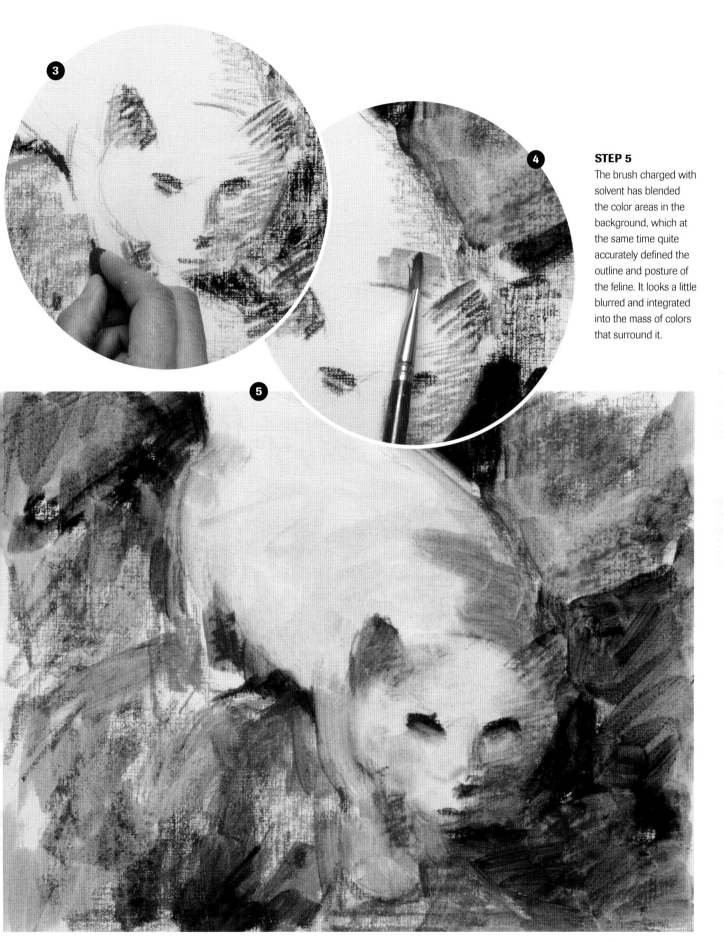

STEP 5

The brush charged with solvent has blended the color areas in the background, which at the same time quite accurately defined the outline and posture of the feline. It looks a little blurred and integrated into the mass of colors that surround it.

Breaking Up the Form

Interest in the Unfinished

The goal is not to achieve a pure abstraction but to learn to value the esthetics of the color and to practice breaking up the form to create a very expressive semi-abstraction, charged with feeling, where the model can still be identified without much difficulty despite the fact that some outlines, edges, or even the face seem blurry and have a sense of being unfinished. The final appearance of the painting should not be much different from what we know as a quick figurative sketch, where the point is to capture the essence and presence of the subject.

Other interpretations of breaking up the form

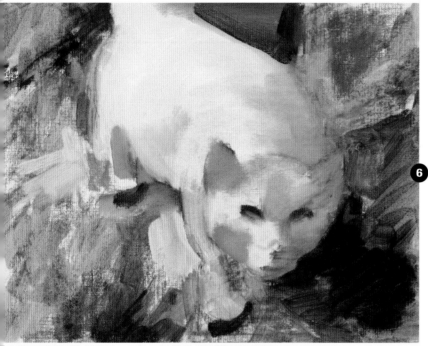

STEP 6

The washes made with diluted oil pastels now give way to wide strokes of opaque oil paint. Paint the fur of the cat with off-white made with yellow, gray, and violet. The tones should blend with each other and only barely allow you to see a few blue lines on the drawing of the head.

STEP 7

Fill the background with new opaque colors that are applied quickly with a gesture of the brush. Some colors should be applied partially mixed, forming streaks where you can see several colors at the same time.

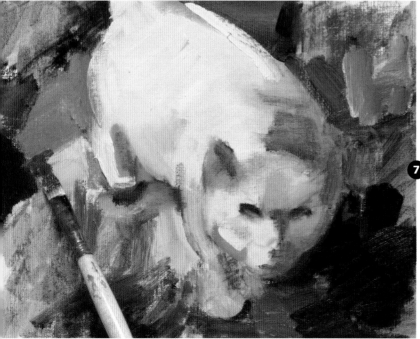

STEP 8

Blend and model the layer of the still wet white paint by just smoothing it with a spatula. In the last phase of this exercise, the tool will be used to break up the outline of the subject even more. Just lightly wipe with the blade to blend the brushstrokes.

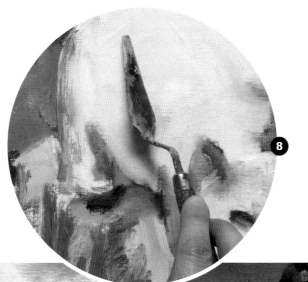

FINAL STATE

Press down with the metal blade of the spatula on the wet paint covering the background to scrape and spread the colors, which will blend with each other to make more neutral and grayish mixtures. Then use the rounded end of the handle to make some small sgrafitto lines that look like scratches. The result is a synthetic simplification of the model.

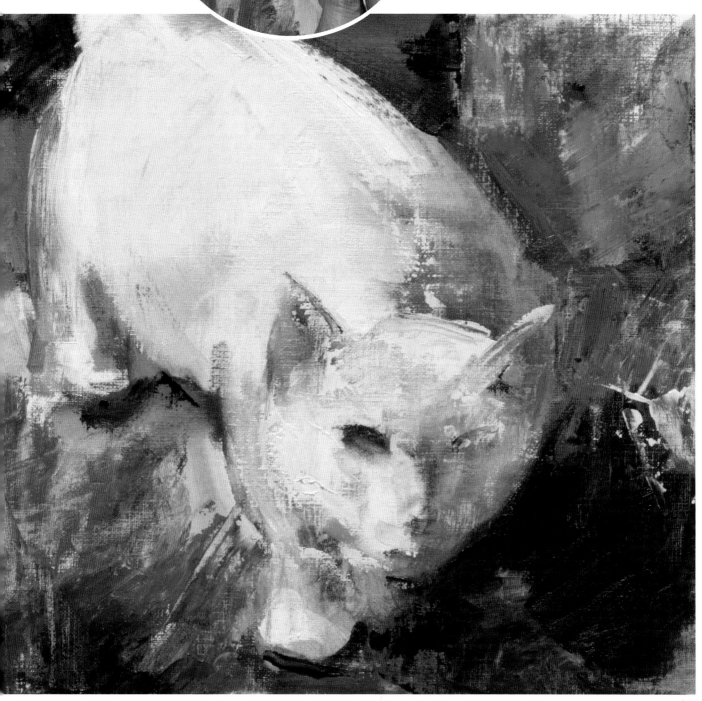

Transformation of a Real Model

2

Up until now, we have demonstrated two very simple ways of approaching abstraction: by using geometry and by synthesizing the color. In this exercise, we will make use of both, blended into a single approach, where the geometric synthesis and the synthesis of color are of equal importance in creating a painting that is halfway to abstraction. The result is very dynamic, expressive, and decorative, and although the forms in the model seem deformed and broken up, you can always make out the subjects that inspired the painting. As you will see, these first exercises are moving toward teaching strategies for reducing and transcribing a real image into another that is potentially abstract. This step-by-step exercise will be done using dry pastels, acrylic paint, and oils.

1

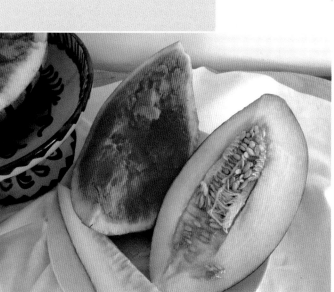

MODEL
Even a classic theme like a still life can be used as a starting point for exploring abstraction.

STEP 1
The support is a piece of gray cardboard on which you will apply some white acrylic paint mixed with a small amount of ochre. The paint should be diluted so that it will flow very easily across the surface of the support.

STEP 2
These first applications of paint have a double function: the first is artistic, laying out the composition; the second is more technical, acting as a primer that reduces the absorption of the cardboard.

3

An Abstract Way of Seeing

You must forget that you are painting a melon and a watermelon. You must develop an abstract way of seeing, considering objects as if they are only masses of color, organic shapes that are only to be synthesized, capturing a few specific details. The brush should be charged with a lot of oil paint so it will flow easily. Each application of color must look fresh and spontaneous and leave visible marks from the brushstrokes.

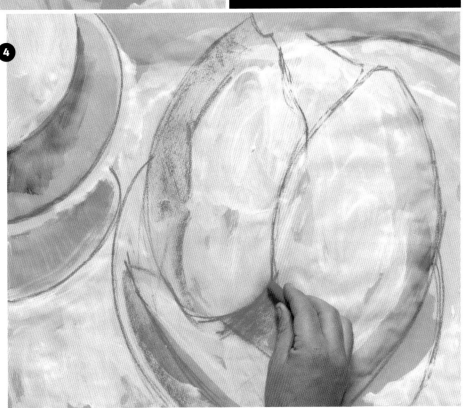

4

STEP 3

Use a small amount of white acrylic mixed with some Prussian blue to apply some shadows in the upper area. These applications should be very diluted, and before you begin to draw let this layer of acrylic paint dry.

STEP 4

Work on a geometric synthesis with a stick of blue dry pastel. This means drawing the model while simplifying the shape of each of the components as much as you can. In this case, the model is constructed using overlapping ellipses and circular shapes.

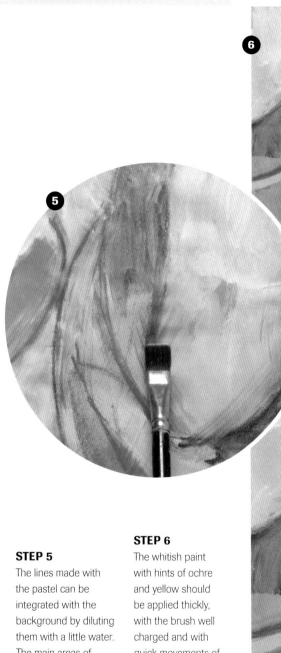

STEP 5

The lines made with the pastel can be integrated with the background by diluting them with a little water. The main areas of shadow are indicated by the first applications of the blue color, which will act as a contrast to the warmer colors that will be added later.

STEP 6

The whitish paint with hints of ochre and yellow should be applied thickly, with the brush well charged and with quick movements of the hand. Some of the strokes follow the outlines of the fruit, whereas others go over the lines and blur them.

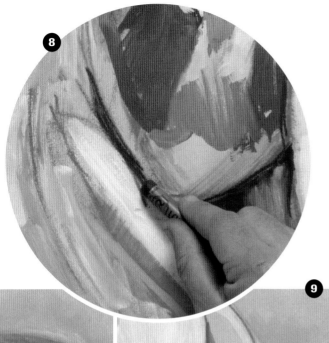

STEP 7

The cadmium red partially covers the watermelon, barely suggesting it, leaving unfinished spaces where you can see the original white. This large red area is going to be the main chromatic focal point.

STEP 8

Add some shading and graphic effects on the still wet layer of paint with a stick of dry blue pastel. Suggest the seeds in the melon with fine, continuous lines, made without raising the point of the stick from the surface of the painting.

STEP 9

Reinforce the contrast between the two oval shapes of the fruit and the background by adding colors around the outside. Work with a harmonious range of colors consisting of carmine, permanent violet, cadmium yellow, and cadmium orange. The light applications of oil paint make the scene more dynamic.

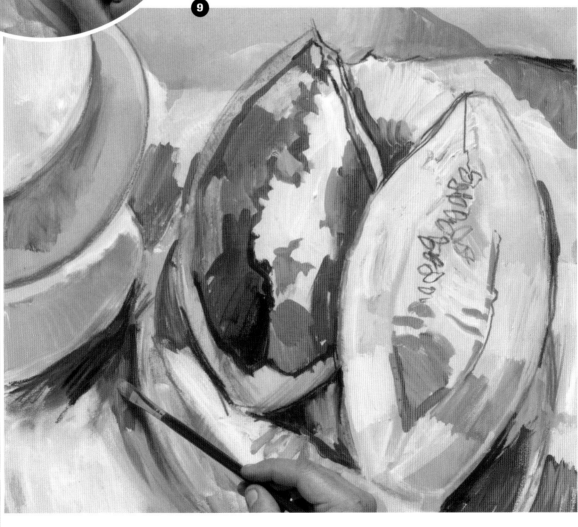

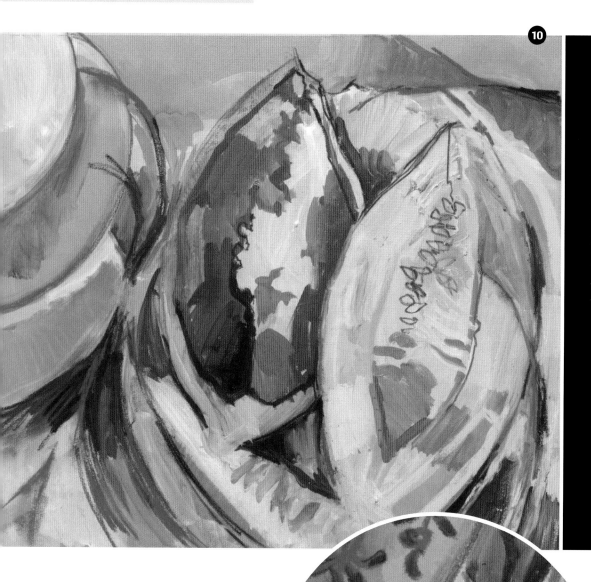

10

Unfinished Is a Step Away from Abstract

It is not a good idea to make the work appear too finished. The best way to avoid this is by removing elements, synthesizing the details, and leaving empty spaces simply covered with areas of flat color that provide a counterpoint to other more colorful areas. The lines are hesitant and very calligraphic; however, their use should be limited.

11

STEP 10

Alternate the use of the brush and the dry pastel, now combining two different tones of blue, applied directly over the fresh paint to create curved lines that go around the bases of the plate and the fruit bowl.

STEP 11

We decided not to represent the contents of the fruit bowl, only to strengthen some of the decorative shapes that are on it and that add more graphic interest to the composition. With this goal in mind, recreate the geometric and organic shapes using both sticks of blue.

Color notes and preliminary sketches for this exercise.

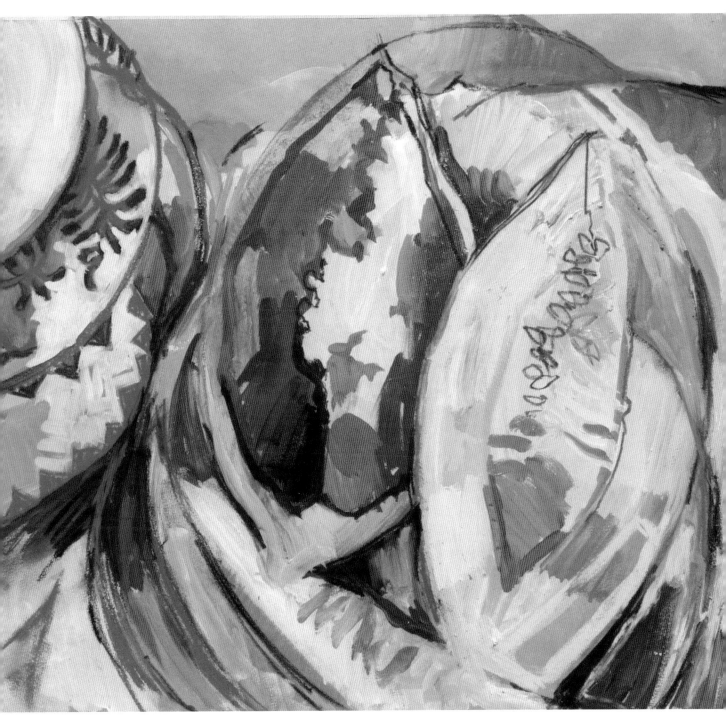

FINAL STATE

In the finished painting, when it comes to the composition, it is more interesting to leave the interior of the fruit bowl empty to compensate for the chromatic tension in the work. Despite the liberties taken with the forms and the development of the color, the work still maintains a figurative connection to the objects represented, although the objects look a bit deformed and affected by the tensions between the colors and the chromatic combinations that are foreign to the model.

The Strength of the Line: Study of a Tree

The next step-by-step exercise involves simplifying the form of a tree, which is achieved by analyzing and emphasizing the basic components. The exercise is based on strokes and lines so that the object you are representing becomes an intermingling of curved lines and colors rather than a description of an actual tree. It is a matter of using the tree as an excuse for making a graphic version of reality, derived from a synthesis of its basic structure, emphasizing and exaggerating some shapes and completely changing the colors so that the final result is attractive. This step-by-step exercise is done on a gray background, combining dry pastels and oil paint.

STEP 1
Before starting, make several sketches and color studies with diluted oils and pastels in an attempt to discover the basic structure of the olive tree. Use one of them as a reference while tackling this exercise.

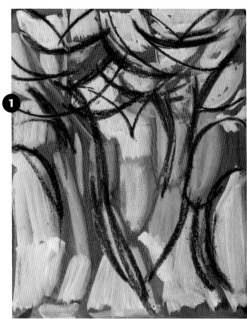

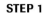

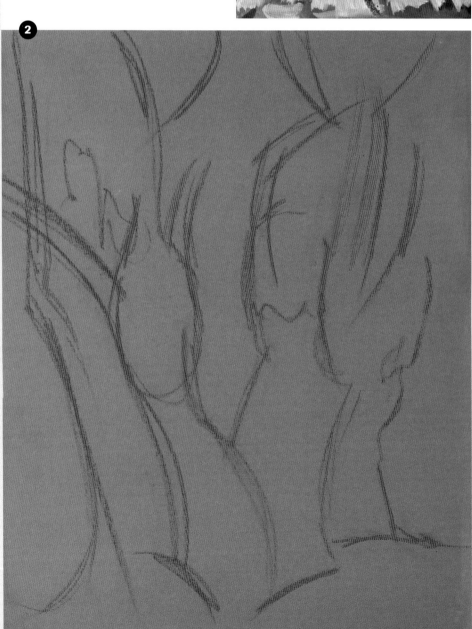

MODEL
The model is an ancient olive tree with sculptural forms. The task is to transform these organic shapes into a solid structure completely dominated by expressive lines.

STEP 2

The first lines should be made with a stick of orange pastel on gray cardboard. The shape of the tree is translated into curved lines drawn with quick motions of the arm. The drawing is quite simple, composed of curved and ascending lines. Draw them while applying some pressure and repeating some lines next to each other. There is not a single straight line.

STEP 3

Now paint with oils. Mix titanium white with a bit of raw sienna and mix another bit of white with Prussian blue; the result is two grayish white colors that you will use to fill in the spaces between the lines.

STEP 4

The background is now covered by the white tones, and a new range of violet colors can be used to paint the branches and the trunk. The paint should be mixed with a small amount of turpentine so it will flow easily.

STEP 5

Finish the first phase of painting by incorporating different tones of light Prussian blue to the base of the tree. At this point, the visual reference of the tree is still very clear, but in the second phase of the exercise it will move much closer to abstraction.

STEP 6

Reinforce the basic structure of the tree, strengthening the lines that define the branches with strokes of orange and cadmium red pastels. When it dries, the oil contained in the oil paint will fix any pastel lines, making them permanent.

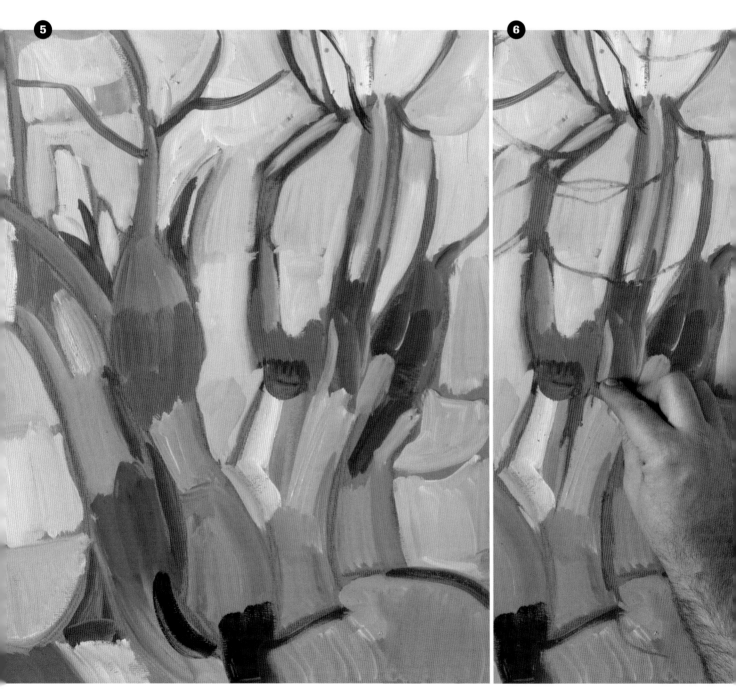

STEP 7

The previous lines should now be completed with more black pastel lines and brushstrokes of Prussian blue using a fine round brush. These new applications will form pronounced curves in the tops of the trees. The goal is to emphasize the dynamic effect of the branches.

STEP 8

Apply new brushstrokes, this time not only in the upper part of the painting but also below so that they suggest a circular shape. Introduce some orange and titanium red, using a few brushstrokes that enliven the scene and blur the outlines of the tree.

The Expressive Power of the Line

In the second phase of the painting, you must emphasize the calligraphic aspect of the work, adding new lines using a stick of pastel that will combine with other lines applied with a fine round brush. The general tendency of the lines will be curved, to generate a sort of net formed by loops that will flood the upper part of the painting.

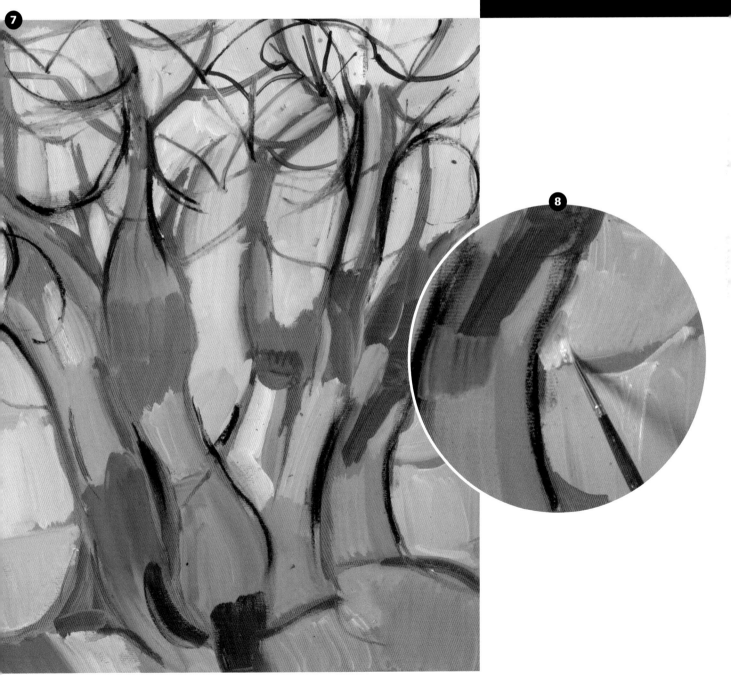

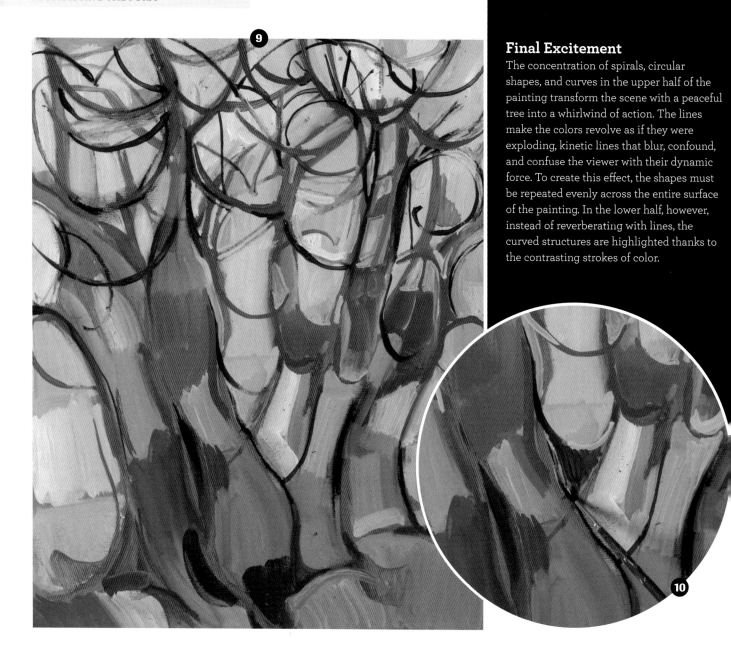

Final Excitement

The concentration of spirals, circular shapes, and curves in the upper half of the painting transform the scene with a peaceful tree into a whirlwind of action. The lines make the colors revolve as if they were exploding, kinetic lines that blur, confound, and confuse the viewer with their dynamic force. To create this effect, the shapes must be repeated evenly across the entire surface of the painting. In the lower half, however, instead of reverberating with lines, the curved structures are highlighted thanks to the contrasting strokes of color.

STEP 9

Little by little, the spiraling lines applied with the brush begin to agitate the scene. The tree undergoes a process of transformation where the figurative reference is being left behind and the action between the colors is strengthened, but even more evident is the exciting and dynamic movement of the lines.

STEP 10

Refine the shape of the trunk until you are left with its fundamental components. Now, apply additional dark strokes of Prussian blue blended with the underlying layer of fresh paint.

FINAL STATE

The finished work is balanced. There is a dynamic graphic feeling in the upper part of the painting, where the initial figurative reference is diluted, and the physical importance of the tree gives way to a representation of its energy.

Preliminary sketches for this exercise

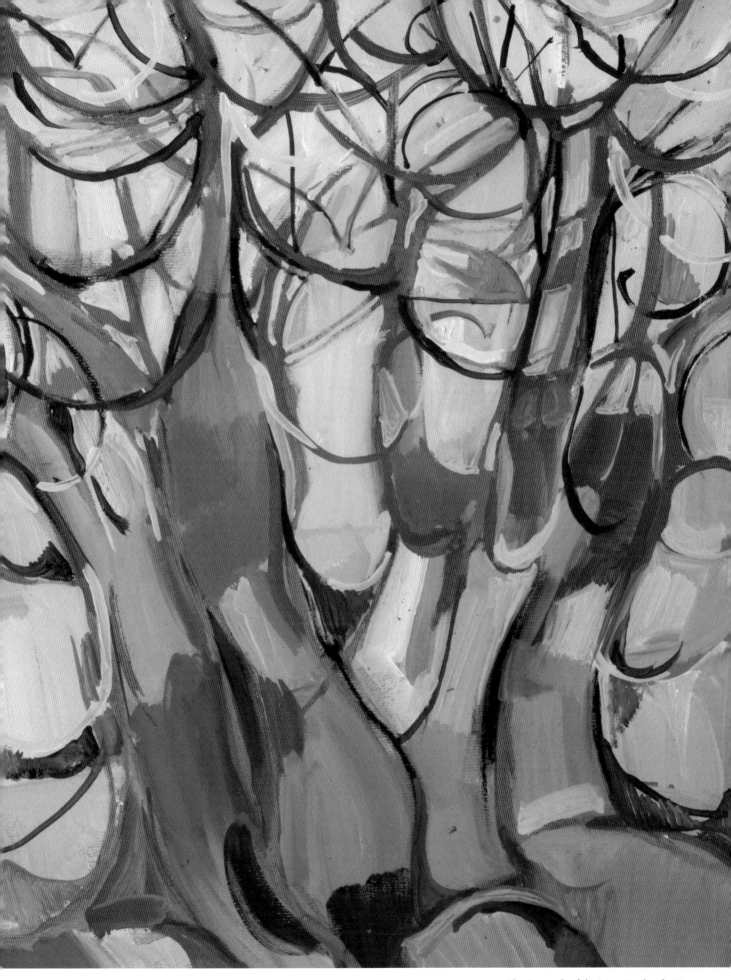

The Strength of the Line: Study of a Tree

The Part as the Whole: Painting a Flower

Another way to explore a real model in the search for subjects for abstraction is to take any photograph and cut out parts until the subject of the photo is hardly recognizable. Focusing very closely on a detail of the model makes the viewer lose the overall view, and the clear and defined object is changed into a mass of colors, curves, and contrasts that lose any reference that the viewer can "lean on." In this exercise, you will put this technique into practice, zooming in to create fragmentation. The starting point is a tightly framed close-up of a flower, to which you will make harmonious changes in the drawing and transform and strengthen the colors to express the personal ideas and feelings of the artist. This time you will be using oil paint.

MODEL

The inspiration for this step-by-step exercise is a very close-up view of a flower, where the outlines of the outer petals will be cut off and any reference to the background will be lost.

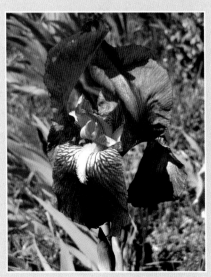

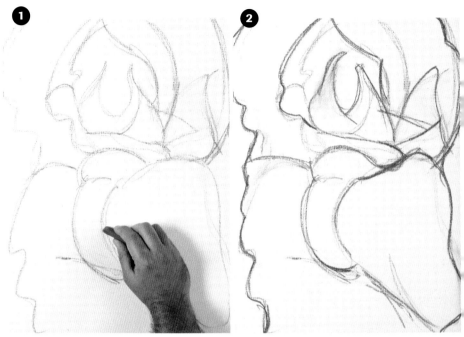

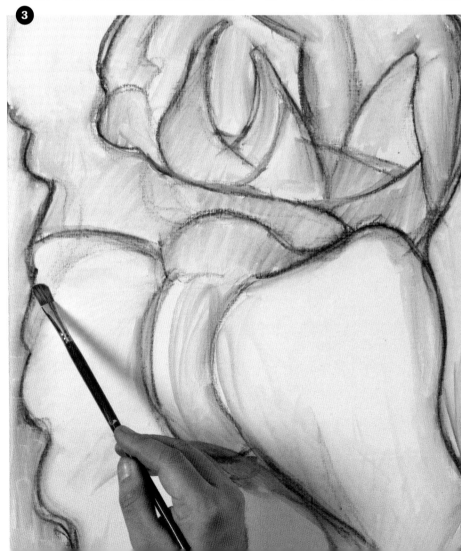

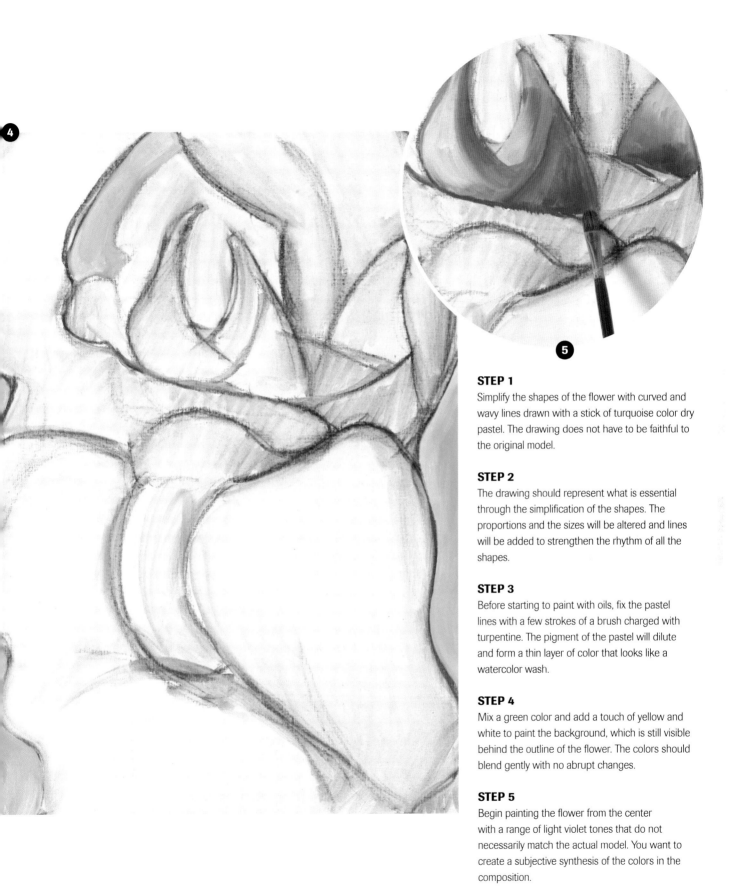

STEP 1

Simplify the shapes of the flower with curved and wavy lines drawn with a stick of turquoise color dry pastel. The drawing does not have to be faithful to the original model.

STEP 2

The drawing should represent what is essential through the simplification of the shapes. The proportions and the sizes will be altered and lines will be added to strengthen the rhythm of all the shapes.

STEP 3

Before starting to paint with oils, fix the pastel lines with a few strokes of a brush charged with turpentine. The pigment of the pastel will dilute and form a thin layer of color that looks like a watercolor wash.

STEP 4

Mix a green color and add a touch of yellow and white to paint the background, which is still visible behind the outline of the flower. The colors should blend gently with no abrupt changes.

STEP 5

Begin painting the flower from the center with a range of light violet tones that do not necessarily match the actual model. You want to create a subjective synthesis of the colors in the composition.

Gradated Petals

After you have completed the drawing of the flower and painted the background, work on the petals, making gradations on each one of them with bright colors. The transitions between tones should be quite smooth and progressive keeping in mind the surface they represent.

STEP 6

Cover another group of petals with some Prussian blue, light ultramarine blue, and cyan mixed with white. The gradations between these different shades of blue will help create a sense of volume on these first shapes.

STEP 7

The exterior petals should be painted using darker gradations of blue. Working with a soft brush will make the blending of the colors easier, and avoid leaving any marks from the brushstrokes.

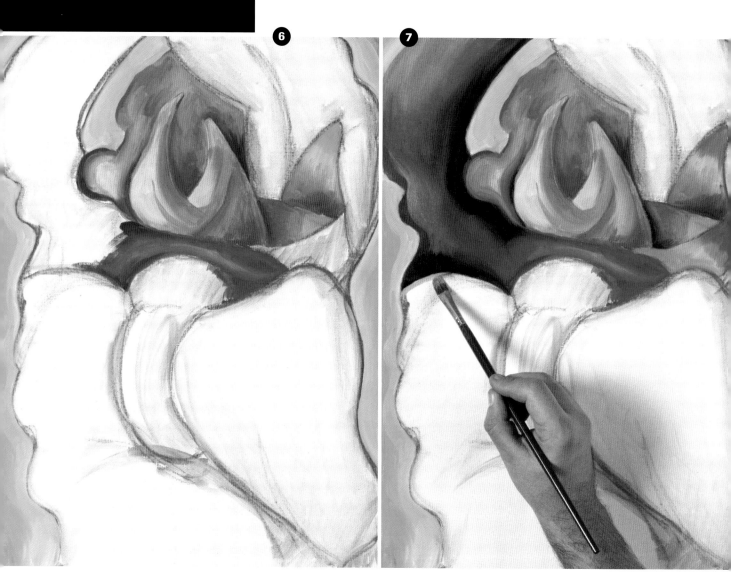

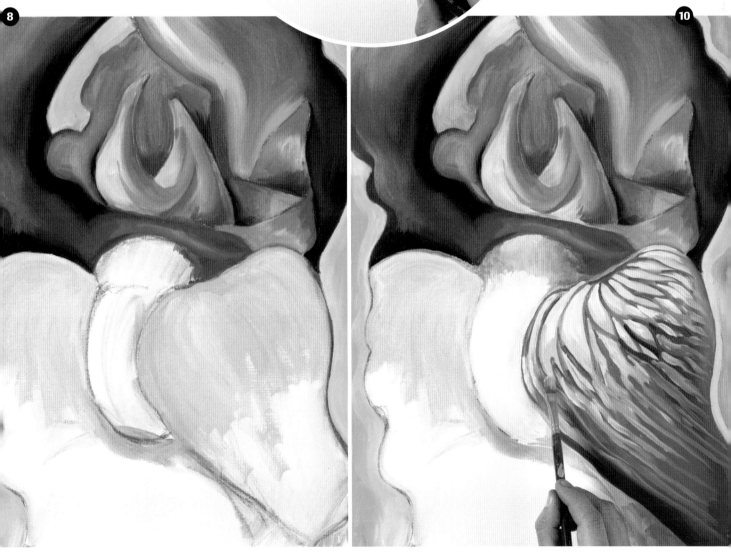

STEP 8

Finish the upper part of the painting with blues, permanent violet, and white. At this halfway point, you will inevitably associate this with the flower, however, nobody is really contemplating a flower now. They instead see a group of colorful shapes that are becoming individual objects themselves.

STEP 9

Now it is time to work in the center of the composition with different tones. Use a pastel yellow and a layer of violet lightened with white to finally cover the white of the support. To blend these colors well, avoid diluting the paint with turpentine.

STEP 10

Over the base of wet paint, brush some blue hatch lines that imitate the pigmentation of the petals of the flowers. The lines will add a more dynamic element to the painting.

Textures and Strong Lines

The lower half of the work is characterized by more elaborate painting composed of crossing lines and more delicate and subtle gradations. They attempt to describe the colored lines on the petals and add a cascading effect that activates the dynamism of the painting. The shapes twist back on themselves and create much tension between each one of the sections.

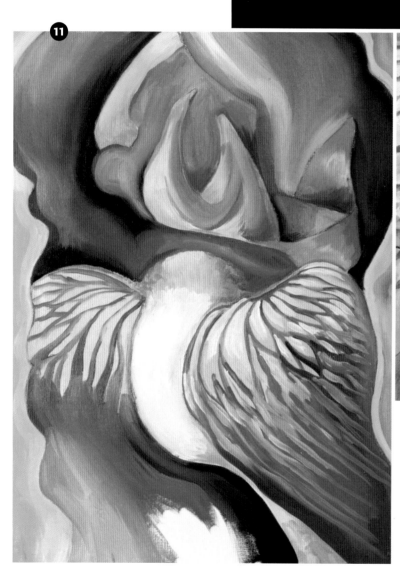

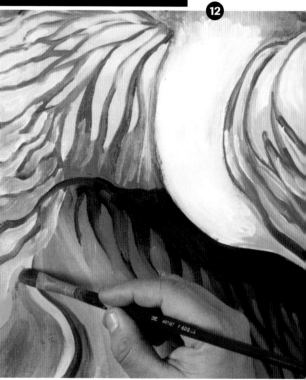

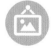

Interpretive variations of the theme in different media

STEP 11

Do the same on the left half of the picture, but make the lines go in the opposite direction. In the lower area, you can see the gradation used to resolve the base color of the petal.

STEP 12

Applying color on the canvas in solid gradations encourages an impression of the firmness and consistency of the material. Amplifying and lengthening the areas of color changes some of the outlines with respect to the reference model.

FINAL STATE

The impression of a realistic work that one has at first glance changes after a longer look as it now has a surrealistic feeling. It is true that you can still recognize some organic elements that remind you of a flower, but the painting is much more dynamic, the lines become more and more turbulent and end up as an organic abstraction where the color becomes the protagonist.

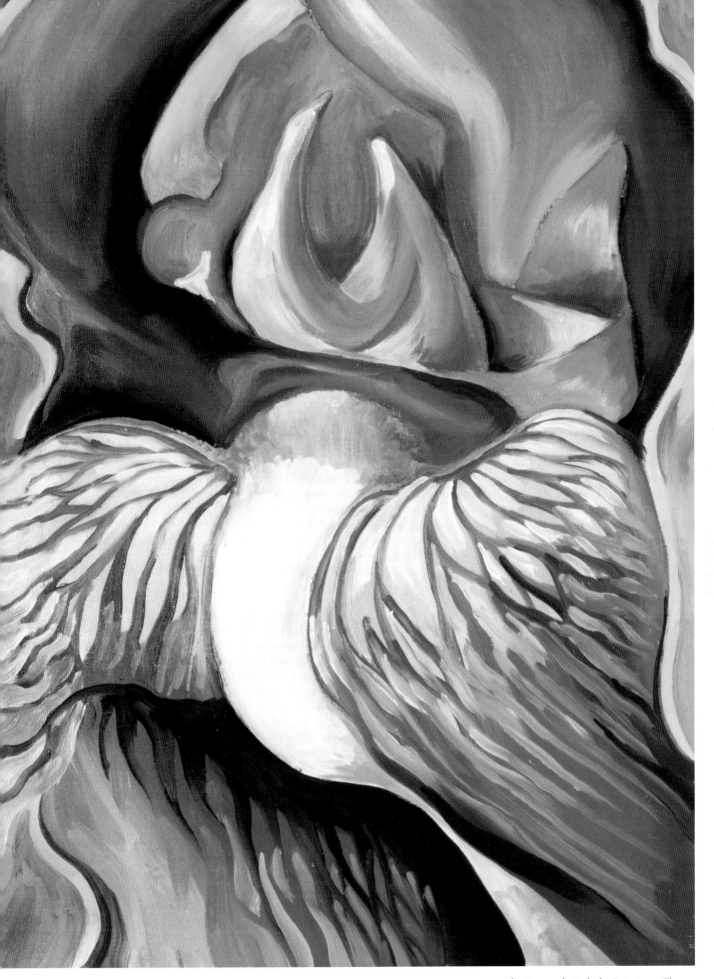

Atmospheric Color: Dissolving the Form

A bstract painting is a space in which we investigate the limits of reality and appearance. There are many strategies for dispelling the viewer's realistic viewpoint and coaxing it toward abstraction. One such strategy promotes a blurred look, unfocused and nearly erased from the reality of the object. To achieve this, the artist can use the *sfumatto* technique. It is often used to give the image an atmospheric feeling and create a poetic vision based on an unfocused image with vague and broken outlines. The next step-by-step exercise is carried out with a limited color range, ambiguous shapes, and insinuated perceptions using a spatula to drag and scrape the paint. You will be using acrylic paint.

STEP 1

First, cover the background with a layer of green paint. Instead of a brush, use a metal spatula directly on the canvas, which will keep the paint from being spread smoothly and evenly.

STEP 2

Dip a paint roller in acrylic paint, diluted with water, and roll it on the canvas with several passes. The goal is to create a blurry background consisting of broken and discontinuous streaks.

MODEL

Here you will be experimenting using the *sfumatto* technique, dragging the paint with a spatula to create a painting of a very simple natural model: a pair of swans.

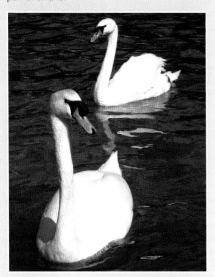

STEP 3

Let the first layer of green dry before painting over it with a yellower green. The paint should be applied with a roller as before.

STEP 4

Now apply emerald green to the support, with the spatula this time, allowing the lighter green to show thorough in just the central part of the painting. Suggest the shape of the swan by spreading titanium white with an artist's spatula with a round tip.

STEP 5

The shapes of the swans are insinuated, with white paint and a bit of orange for their beaks. The edges are imprecise, but still too clear, so in the next phase you will make these elements look even more abstract.

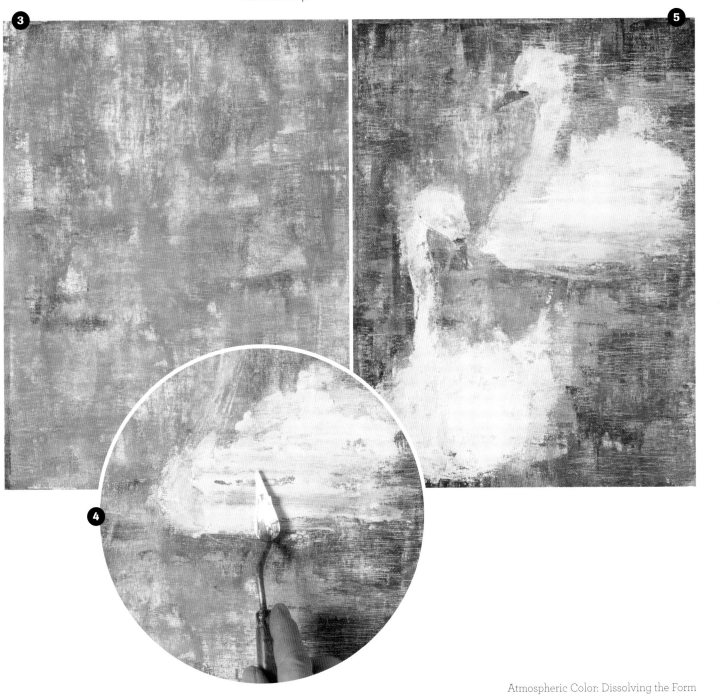

The Spatula as a Sign of Vagueness

Let us not be confused by the task of reinforcing the dark tones in the background. The goal continues to be to create a hazy, blurry image of the swans that will not be very easy to identify. The work should all be done with a spatula, which will discourage making any corrections of details and spread the paint far and imprecisely.

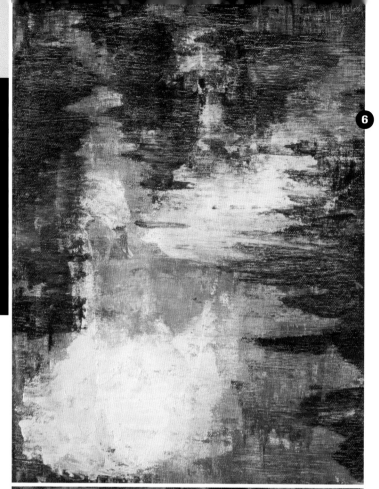

STEP 6

The creation of the *sfumatto* should weaken the forms and make their outlines more vague. Therefore, it will help to bring back some of the dark tones and give the image more strength. Apply undiluted paint, which is easier to work with.

STEP 7

Use the flat spatula to apply a very light violet to dilute the shapes even more; finish with a pale orange tone and some dabs of grayish blue to emphasize the contrasting light.

Dragging the spatula makes streaky mixtures of color. If you press hard, the layer of color will be very thin and the effect will be similar to glazing.

FINAL STATE

The final result will be atmospheric, fresh, and elegant. The birds should be indicated with striking streaks of color that remove them from a realistic representation and fully submerge them into the world of abstraction, which does not respect outlines, but does encourage a more energetic interpretation created with a range of limited colors.

Other results of atmospheric painting

Atmospheric Color: Dissolving the Form

Pure Abstraction with Fluid Colors

Working with fluid paint is a way to achieve some very surprising results, abstract works with a strong spiritual and poetic feeling. The goal of these paintings is not to deconstruct a real form, because the starting point is uniquely without form. It is abstraction without any reference at all, pure experimentation with color and with the fluidity of the paint. Let yourself be carried away by chance and forms that, on their own, begin to appear on the canvas. Both acrylic paint and oils can be used, and both render surprising results. Let's look at some examples.

1 Liquid acrylic paint is poured on a canvas in a horizontal position. It is mixed with latex diluted with water and a little ash to give a rough look to the gray colors.

2 Here each application of paint was previously mixed in a container and then poured on the canvas, allowing the shapes to slowly appear. A thick mixture of latex, acrylic, and ashes will sometimes cause cracks to appear, which adds a very interesting textured surface.

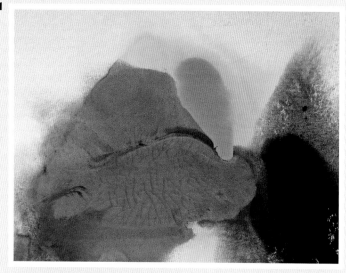

1

2

3 This work was made with oils. The artist spread the paint with a spatula to create ragged edges and blended some areas with the fingers. The layers of paint are saturated, opaque, and transmit a strong sense of energy.

4 When working with thick, opaque paint, it is not necessary to place the support in a horizontal position. The shapes are created freely with quick strokes with the spatula, guided not by any model or visual reference but by the artist's imagination alone.

5 These applications of paint were made on a horizontal canvas. The paint was allowed to puddle and then the support was tipped so that the dilute oils could flow upward to create interesting gradated effects as it moved.

The Human Figure as a Model

Here the subject of inspiration will be the human figure. It will be dangerous: allowing yourself to follow the real reference too closely will result in a final painting that looks like an excessively realistic work. To take the representation more toward abstraction, it will be necessary for the relationship established with the model to be iconic, that is, sustained with only a few signs that imitate the object or that have at least some feature in common with it, like the outline of a face, the structure of an arm, or the position of the body. The word *iconic* implies a similarity but not exactness. It suggests a coinciding with the object in certain features or properties, although to create a painting that is more abstract, it is important for the likeness to be limited. Later, the few visual references that are related to the figure should be disguised, hidden behind colors and structure that make identifying them more difficult. The following step-by-step exercise will be done using oil colors.

PRELIMINARY SKETCH

Before directly approaching the subject, it will be helpful to make a quick preliminary sketch or color study with oil pastels. From there, you need to decide where to place the focal point and which colors to use in the painting.

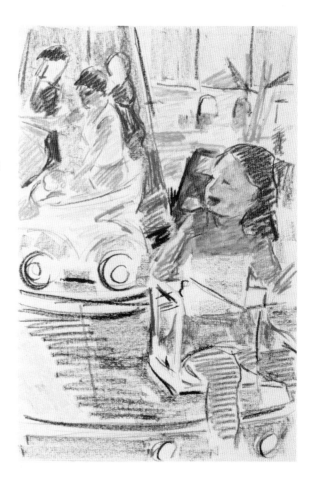

MODEL

The human figure does not appear in the center of this scene, but as part of a dynamic group that stands out against the colors and shapes in the background.

❶

STEP 1

Draw the main lines of the composition with a brush charged with diluted cobalt blue paint to indicate the structure of the drawing. It is important to fix the location of the figure and also the balance of the different masses of color that will be in the painting.

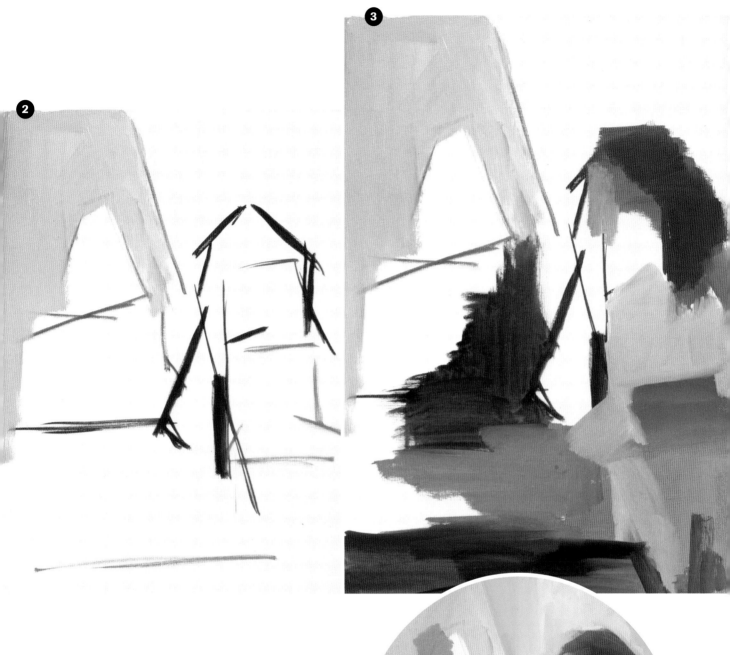

STEP 2

The first passes are purely exercises in composition in which you will simplify the elements with a few geometric shapes that can then start to be combined using strokes of flat colors.

STEP 3

Although the applications of color are inspired by the local colors of the model, they are added using a wide palette knife, quickly and without any detail at all. The different shades should be slightly blended with each other.

STEP 4

It is a matter of putting into practice the process of synthesizing that is so clearly explained in the first part of this book. The goal is to cover the white of the support and to create a base that you will continue to work on.

5

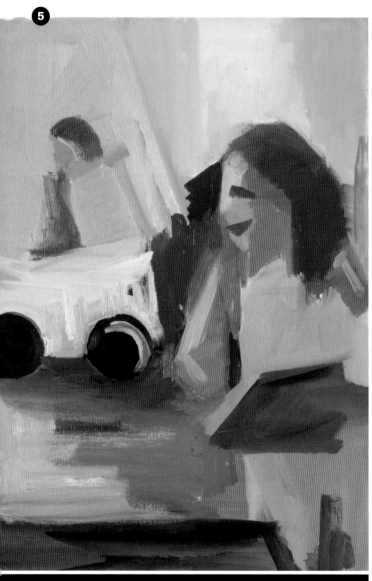

6

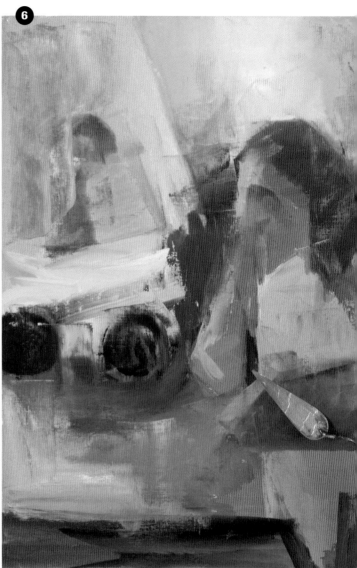

Deconstructing the Form

After you have determined the structure of the painting, dilute the outlines. Do this by breaking up the precise edges between the areas of color, using brushstrokes to blur them, or by scraping the layer of wet paint with the metal blade of the spatula.

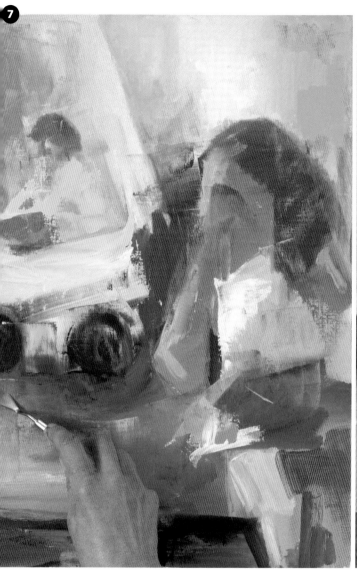

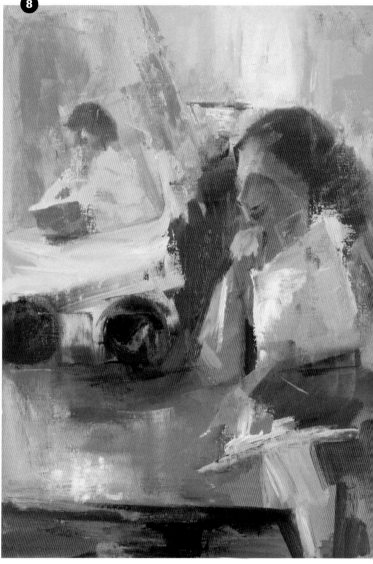

STEP 5

The advantage of working with oils is that they have a long drying time, so that a layer of paint can be manipulated and blended and new colors added to change it. At the end of this first phase, the painting will have a clear geometric tendency.

STEP 6

Work directly on the layer of wet paint with a metal spatula, blurring the outlines and blending some of the adjacent colors with each other. Remember that the relation with the figure should be purely iconic or symbolic. Do nothing to make it more visually recognizable.

STEP 7

Use a smaller spatula to finish the edges that are going to be cleaner and more contrasting, and incorporate touches of new color to the background.

STEP 8

After the background has been resolved, shift your focus to the figure on the right. The goal is to add greater complexity and richer colors by overlaying color impastos that give it a somewhat more solid appearance.

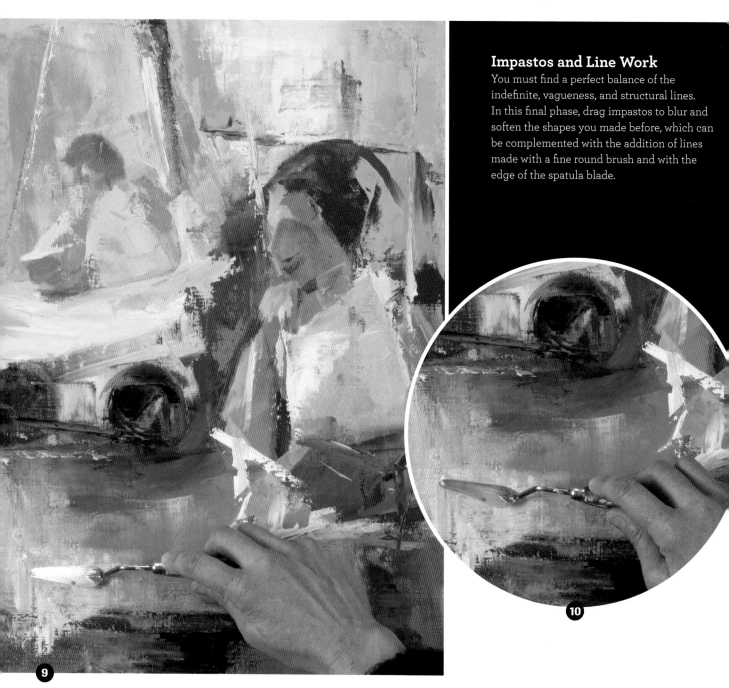

Impastos and Line Work

You must find a perfect balance of the indefinite, vagueness, and structural lines. In this final phase, drag impastos to blur and soften the shapes you made before, which can be complemented with the addition of lines made with a fine round brush and with the edge of the spatula blade.

10

9

STEP 9

The areas of flat paint can be complemented with others made using the blade of the spatula. Light dragging will create linear shapes that will help in deconstructing the painting even more.

STEP 10

Neither the areas of color nor the linear shapes are defined; all of the additions of color tend to blend with each other and help to destroy the edges of the forms.

FINAL STATE

Add a few touches with a brush to the head of the figure (the rest of the body should be left undefined, constructed of wide paint strokes); then add new lines that drag along some of the layer of paint that is still wet. Without the suggestion of the girl's head and the human form in the background, the work would be completely abstract.

A different version of this exercise with a more figurative color study

ABSTRACTION BASED
ON COLORS

In abstract paintings, colors are expressed freely since they do not describe the volume of an object. They acquire an essence that turns each of them into an autonomous element, whose only job is representing itself. Color is used to emphasize, highlight, suggest, and reduce the building up of forces and tensions between different parts of the painting. For this reason, it is important to master the painterly approaches in the application of colors to create expressive results. It is obvious that in abstract painting the colors can be adapted to all kinds of detours, but to be able to apply them accurately, you must remember certain aspects: how to synthesize, control the composition, develop a wide range of colors, and construct or deconstruct (if necessary) a form through the use of color.

Interior of a Train in Monochromatic Color

The following step–by–step exercise is not attractive in the way that a painting that has bright colors is, but it is notable for the strength of its lines and the harmony created by the use of monochromatic colors. The goal is to know how to interpret any model in an abstract manner, no matter how uninspiring it may be. You can do this by making a preliminary study to develop some early basic ideas into a few sketches that can be finished in just a few minutes. Use your results achieved during the sketching phase; choose one of your color studies as a starting point for developing a somewhat more finished work. In this demonstration, we have used oil paints combined with aniline inks on a poster board type paper.

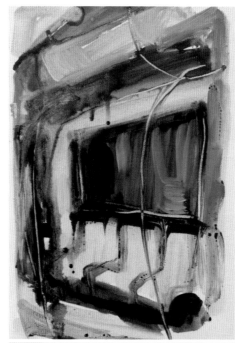

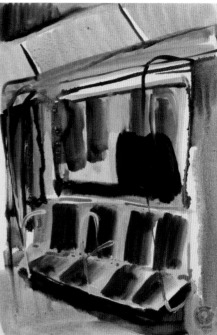

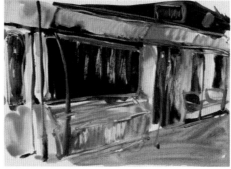

PRELIMINARY STUDIES

First, look at the model in question from different points of view to make some notes and sketches that all have in common the use of monochromatic grays. You only have to spend a few minutes on each study, enough to become familiar with the technique and to decide what approach you will take in the painting.

MODEL

After going over many points of view and different framing options, we chose a perspective view into the subway cars.

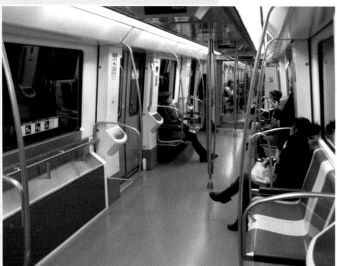

STEP 1

The drawing is made directly with the applicator from the bottle of aniline color, using it like a reed pen. We have chosen to use sepia brown, making heavy and dark lines.

STEP 2

The drawing of the interior of the car is bold and dynamic and shows a certain amount of distortion in the perspective. We strengthen the perpendicular lines in the center of the painting, adding many more than there are in the original model.

STEP 3

We fill in the white spaces that appear between the sepia lines with an ink of sienna color, again using the dropper on the lid. The ink forms puddles and even drips, which you should not try to avoid.

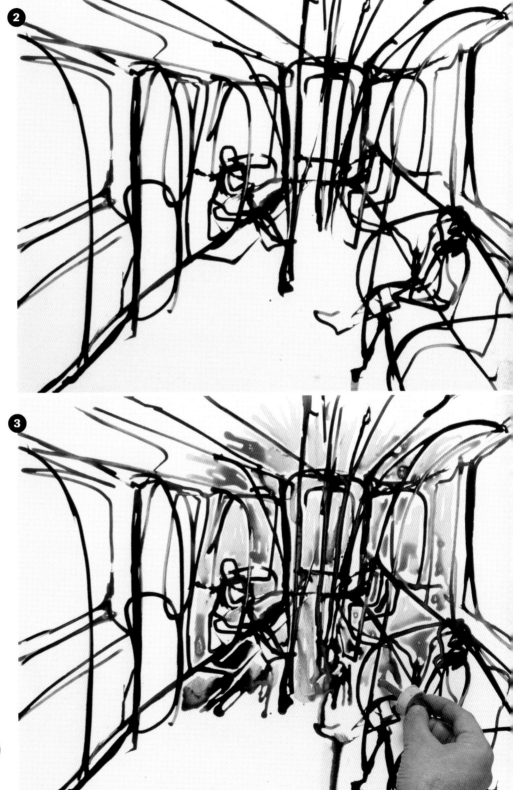

Interior of a Train in Monochromatic Color

Another version
of the model by
the same artist

Diluted and Dirty Paint

After you have finished a working session with oil paints, you are usually left with a container of dirty turpentine and gray sludge, left over from mixing many different colors. Use this muddy diluent, which tends to turn any color it is mixed with gray, in the first applications of oils. A few glazes of semitransparent gray will be used to completely cover the white of the support.

STEP 4

Let all the work done in ink dry for one hour, or use a hairdryer, set on cold, to accelerate the drying. After the paper is dry, apply oil paint that is heavily diluted with the turpentine and sludge left over from a previous painting.

STEP 5

Over the base of diluted gray–blue, paint the windows and sketch two figures with ivory black. The paint is thicker and the brushstrokes should be quick and loose.

STEP 6

Begin filling in all the spaces between the lines with titanium white diluted with the same dirty turpentine used to paint the paper. The white will be full of gray streaks.

STEP 7

The white tones should be mixed with blue, black, and even a touch of ochre to create different shades of color. When the entire surface of the support is completely covered, take a spatula with a round tip and scratch with it to recover some of the lines underneath and to make some new ones.

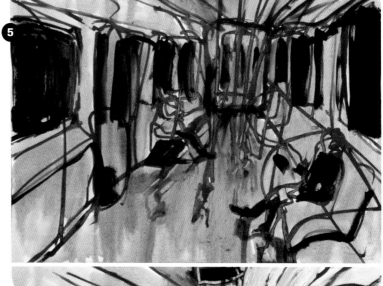

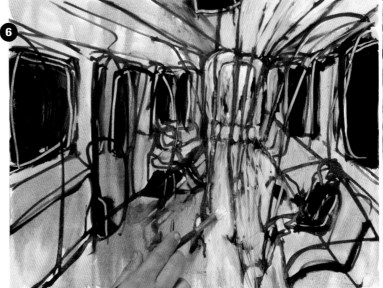

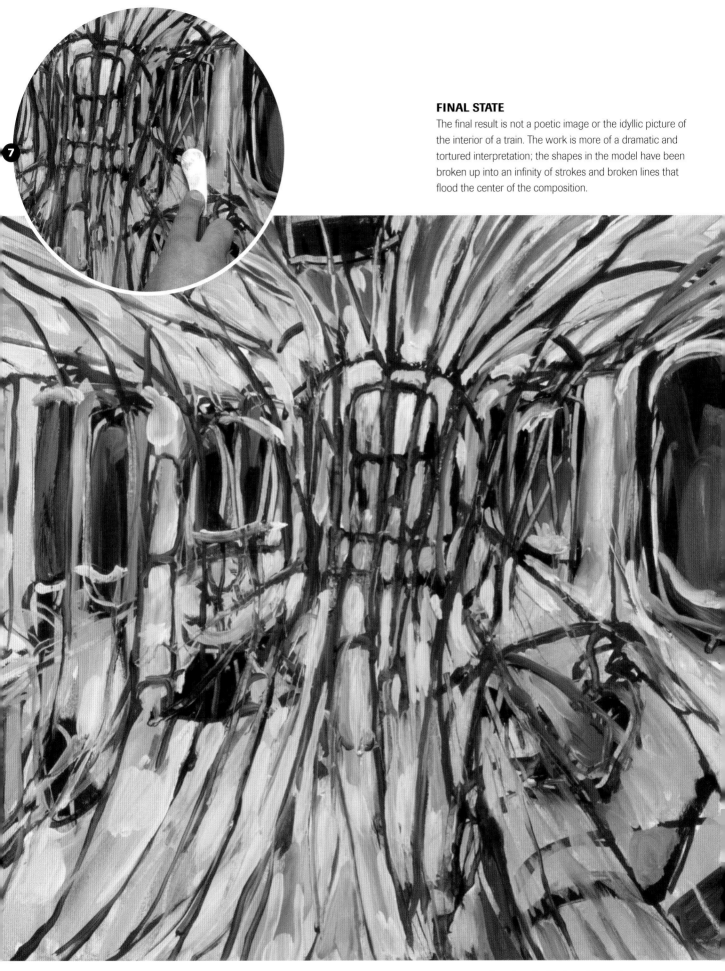

FINAL STATE

The final result is not a poetic image or the idyllic picture of the interior of a train. The work is more of a dramatic and tortured interpretation; the shapes in the model have been broken up into an infinity of strokes and broken lines that flood the center of the composition.

Interior of a Train in Monochromatic Color

Abstract Landscape with Fields of Color

Landscapes have been one of the main sources of inspiration for many abstract painters. This is because the genre is organized in a natural way—organic, balanced, and dehumanized—and therefore, it is often enough to place a few bands of approximated colors to define each plane to create a simple abstract composition. In this exercise, we return to our interest in saturated colors and demonstrate how a composition with plants taken from any landscape can be used as the basis for a nonobjective painting. The work consists of applying compact blocks of solid and well-structured color. Acrylic paint will be used for this approach.

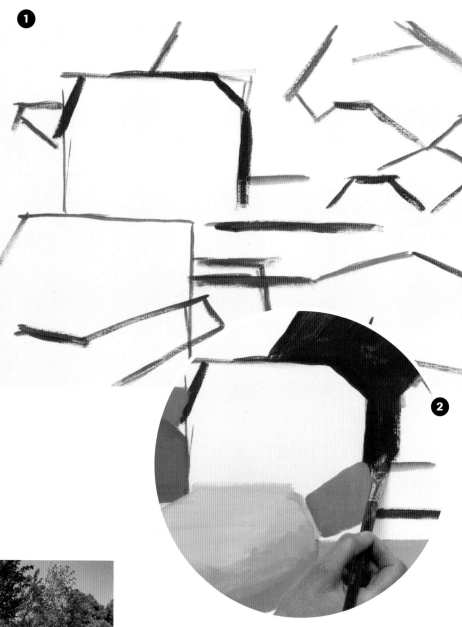

MODEL

A group of bushes with varied colors is a good excuse for creating a composition with solid chromatic structures.

STEP 1

There is no need for a preliminary charcoal sketch; a brush charged with diluted acrylic paint will be the main instrument for creating structure in the painting. Begin by sketching the position of each component with just a very few lines.

STEP 2

The first additions of paint should be thick and smooth. Apply them in blocks, creating solid shapes that fill up each of the white spaces within the lines you previously painted.

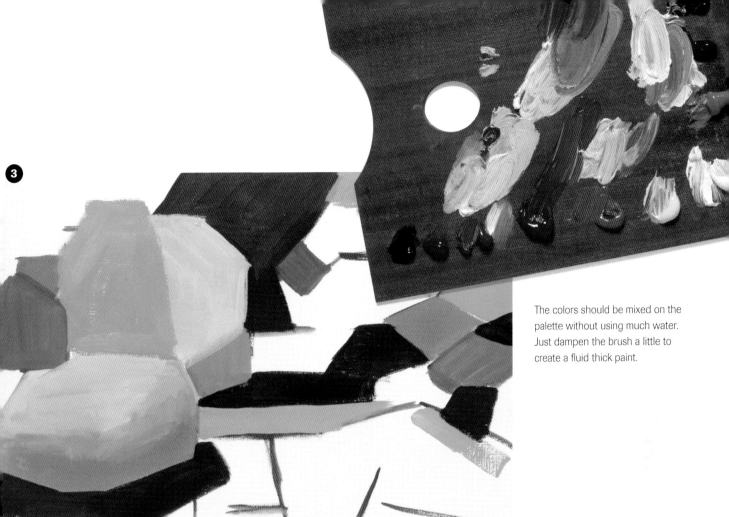

3

The colors should be mixed on the palette without using much water. Just dampen the brush a little to create a fluid thick paint.

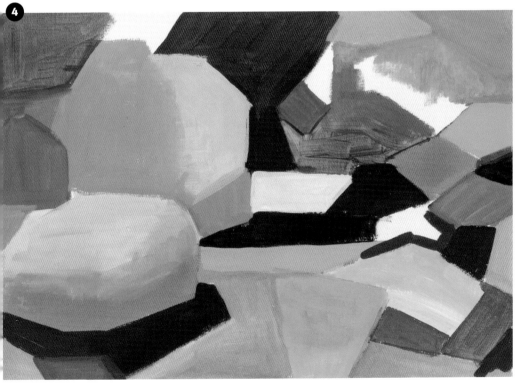

4

STEP 3

The painting should be built up as if it were a puzzle; each unit of color should fit into the adjacent units in a very orderly way. In the beginning, the shapes will have a clearly geometric tendency.

STEP 4

The lower part of the painting is completed with the addition of light ochres with well-defined edges. The fast-drying acrylics help keep the colors from accidentally mixing when you are painting the edges.

Abstract Landscape with Fields of Color

Clean and Opaque Colors

When acrylic paint is applied pure and thick, the work acquires great solidity. Here blending and mixing are not worthwhile, this is abstraction based on combining blocks of saturated colors. Some gradation effects can be created to add more strength to each zone and to break up the monotony and sense of flatness of the colors.

STEP 5
Notice that despite working with thick opaque acrylics, when the paint dries, it becomes transparent, and the underlying layer of paint shows through.

STEP 6
Apply a new layer of paint over the base colors that have completely dried. This time take a different approach, mixing the different tones using short and repeated brushstrokes that break up the uniformity of the colors.

FINAL STATE
After the final additions in the center of the painting, the final image is full of color and vitality. The exercise is very simple, but striking, the contrast between complementary colors dominates: oranges and blues, scarlet and green, and such. They create changes in value and light that enrich all of the colors that are involved.

Different varieties of abstraction inspired by the natural landscape

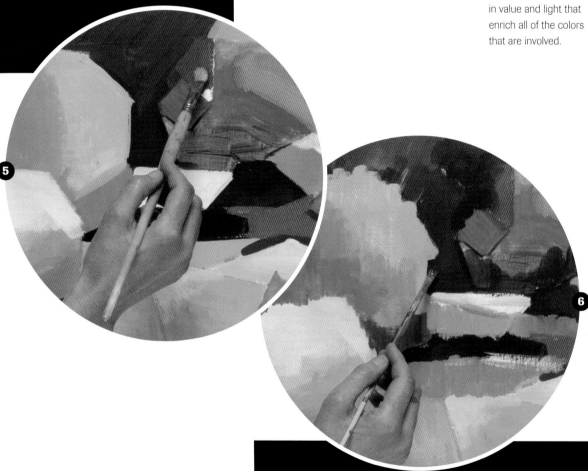

Decorating the Painting

When the structure of the painting has been completed, the final phase of the work is usually devoted to "gilding the lily," that is, emphasizing the painterly effect of the work with small additions that decorate it and make the message more attractive. These should be strokes of bright colors that underline and accentuate some aspects of the painting.

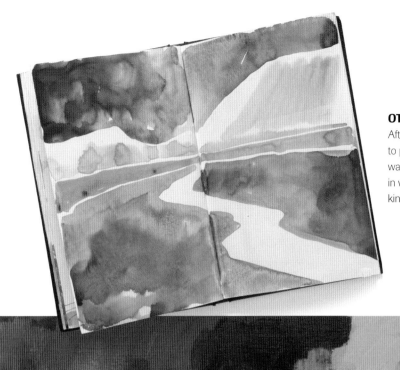

OTHER CREATIONS

After finishing this exercise, you will be inspired to practice making other studies with acrylics or watercolors to try to synthesize more landscapes in which it will be possible to experiment with all kinds of ideas for new creations.

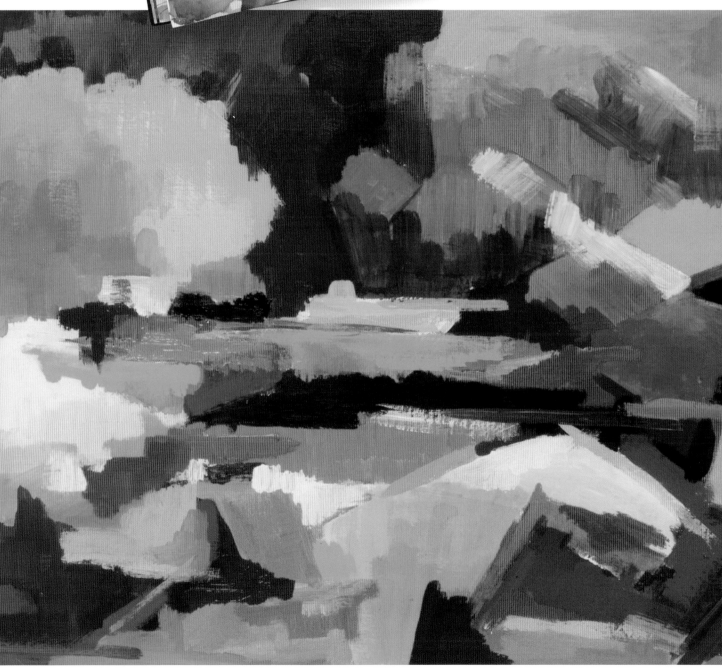

Abstract Landscape with Fields of Color

A Look at Abstracting the Landscape

Color is a powerful tool for organizing an abstract work that is inspired by a natural landscape. It allows you to interpret it with a base of fluid washes that weave together to form a solid structure that is not very detailed and avoids the representation of elements like trees, bridges, and rivers in an obvious manner. The colors you use to sketch a landscape are not a thoughtless and random accumulation, but an attempt to create balance, distributed in such a way that each color compensates for the next.

1 With a few color washes, any landscape can be transformed into an abstract interpretation. It is a good idea to follow a structure, alternating the colors but with a certain sense, leaving some areas blank.

1

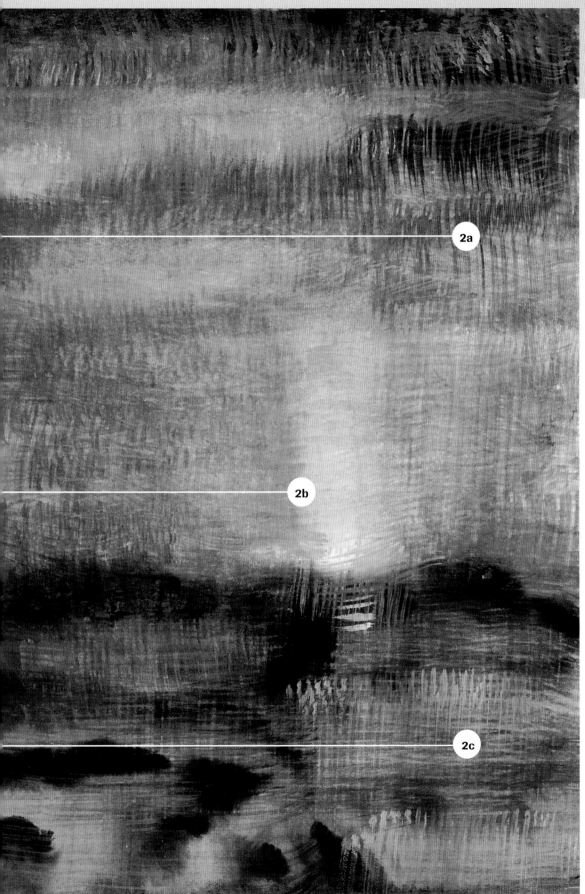

2 This freely painted landscape is based on suggestive overlaid watercolor washes and rich blending. These techniques ignore the forms and move the work away from a figurative toward a totally abstract painting.

2a The fine and long brushstrokes in the upper area were made with a fan brush charged with thick watercolor.

2b The background of the landscape was begun by overlaying diluted washes with a wide brush, blending the colors with each other.

2c The brushed effects are made with a flat sponge brush, which drags thc paint and blends the tones while leaving a very characteristic pattern.

Acrylic Washes

Acrylic paint is versatile and durable and can be used for experimenting with the wash technique, which consists of applying layers of paint as glazes and then removing part of them with a roller or brush soaked with water. Varying the motif and the manner of applying this technique, which can even be combined with impastos, will create an interesting and varied gallery of works that range from subtle and atmospheric finishes to intense direct applications.

1

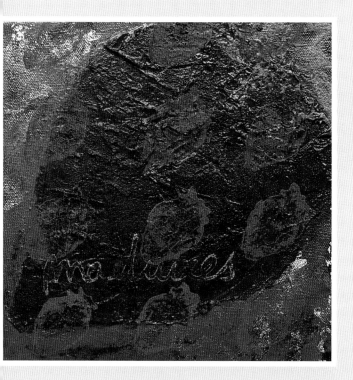

1 This monochrome painting was made using number stencils and gray washes. They were applied wet and unevenly, making horizontal bands that add a whitish veil to the work.

2 Here the washes of acrylic paint are very similar to work done in watercolor. The shapes look like cut out or torn pieces of paper; the shades are created by overlaying transparent colors.

3 To create the translucent look of the black shapes that look like the leaves of a plant, they are allowed to dry partially and then a wash is applied with a wet brush that removes part of the layer of paint.

4 Here the approach is to work in different ways by applying different types of washes on a single shape. A very subtle wash is applied on the graphic letters, and a more striking wash is applied with a cotton rag and a sponge on the shapes of the strawberries.

5 This time, the wash technique is applied on the petals of the flowers and the letters, removing part of the paint with a damp sponge. After allowing the paint to dry, the reds and pinks are overlaid to add color to the painting.

Liquid Media: Working with Fluids

The many liquid media and their different traditional and contemporary processes, including those that imply breaking the rules of the better-known media, can become very interesting resources for the lovers of abstract painting. When you are working with watercolors, anilines, and inks, the colors will be of a luminous, pure, and brilliant nature that is not usual in other media like oils and acrylics. The liquid media leave part of the creative process to chance, not depending directly on the action of the artist on the paper but on the (somewhat random) intentionality of washes on wet, which form textures and movement of the paint that not only break up the sameness of the picture plane, but add an interest based on its organic shapes. The following exercise is done with a combination of acrylic and aniline inks.

MODEL

When painting with applications of inks and washes, it is best to choose a model based on organic forms, in this case a small cove flanked by large blocks of stone.

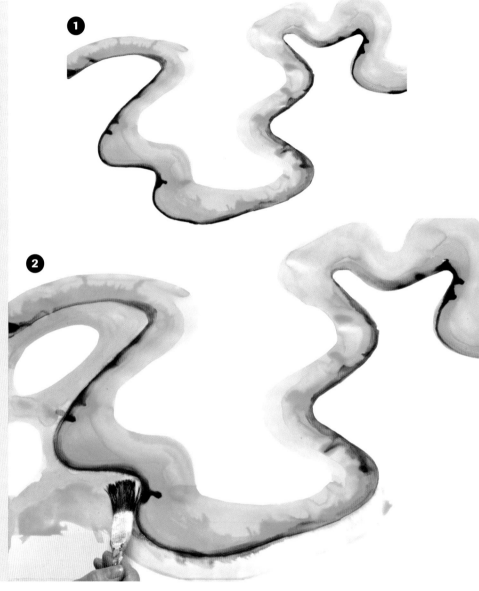

STEP 1

You do not have to be faithful to the model, but you should try to capture the spirit and the wavy lines that are along the edge of the water. First, draw a line with the applicator of the aniline ink, and then add washes of green to make it run.

STEP 2

Use a wide brush charged with very diluted emerald green to paint the area below the line. You do not have to wait for the previous washes to dry; you actually want the colors to run when they come into contact.

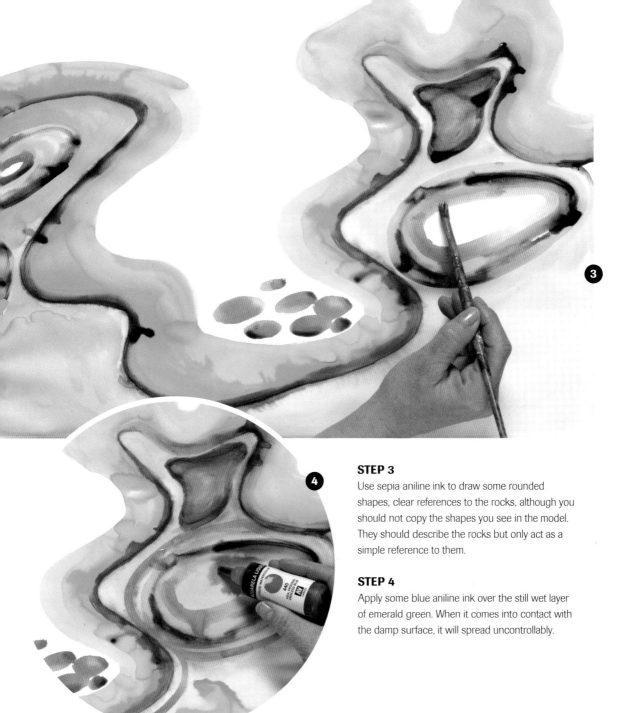

STEP 3

Use sepia aniline ink to draw some rounded shapes, clear references to the rocks, although you should not copy the shapes you see in the model. They should describe the rocks but only act as a simple reference to them.

STEP 4

Apply some blue aniline ink over the still wet layer of emerald green. When it comes into contact with the damp surface, it will spread uncontrollably.

It is a good idea to always have at hand two or three pieces of the same paper as the one used in the exercise for experimenting. You must see how the paint reacts so that you can try out possible effects that you might want to incorporate into the final painting.

Capturing the Spirit

Painting abstracts is more like painting the souls of things, their spirits, or the forms that suggest them rather than describing them. With this goal in mind, the painting changes exponentially and the development of organic forms increases with a range of colors that are chosen by the artist and have nothing to do with the model that serves as the inspiration.

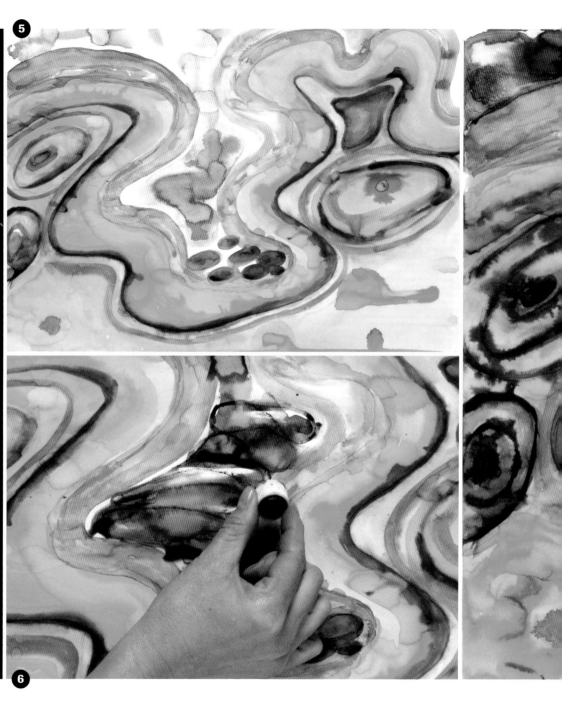

STEP 5

Complete the center area of the picture with magenta washes and a very faint grayish blue to strengthen the compositional loop formed by the lines.

STEP 6

A new layer of scarlet and violet colors will contrast with the dominant green. Do not apply the ink with a brush but directly with the dispenser on the cap.

FINAL STATE

The painting is now finished. The recreation of this corner of the beach is quite interesting. It is obvious that the shapes were inspired by the model, but the colors and the interpretation move it so far away from the original that it is difficult for the viewer to see a direct relationship with the photographic reference.

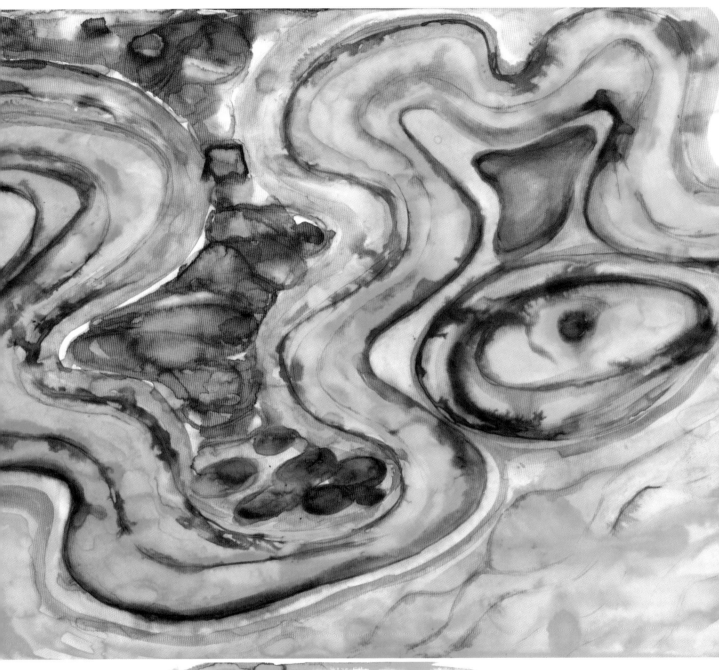

Color studies
made previous
to painting this
exercise

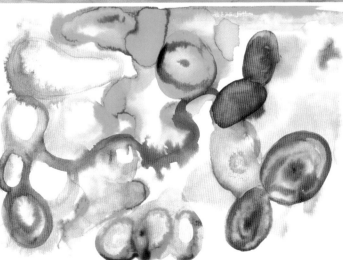

Even if you paint this model several times, the results will always be different because with each new version the artist will attempt to discover new shapes and apply different solutions that give free range to his or her imagination.

Color Glazing with Acrylics

Any painting media can be used for experimenting with transparent colors, building up successive translucent washes to create an abstract composition that is more subtle, poetic, and atmospheric. Success in working with this technique will depend on the artist's ability to control the washes, varying the transparency of the colors and producing bare spots with a painter's roller when the wash has only partially dried. In the following step-by-step exercise, you will paint with acrylic washes much as you would with watercolors. You will take advantage of the extreme wetness of the medium to make full use of spreading the pigment by using glazes and gradations and by allowing it to puddle.

STEP 1

Before starting to draw, prepare the surface of the support with acrylic paint spread with a painter's spatula. The colors are very pale, a pink tone and a gray one.

STEP 2

Allow the first layer of pale acrylic to dry and then make a rough layout of the structures of the buildings. Do this by using the side of a graphite stick to make very thin and barely visible lines.

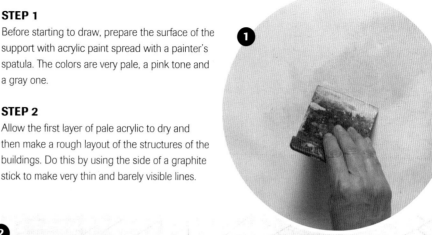

MODEL

An urban scene with brightly painted façades is a good subject for a painting, as long as you take inspiration from some aspects of the model and barely conserve any figurative references.

In this first phase of the painting, you will use a wide brush and a spatula, mixing a dab of color with a large amount of white.

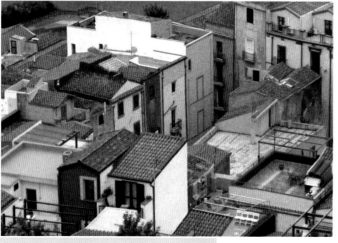

STEP 3

The first masses of color should be spread with a wide brush to create a thin film of paint that will almost immediately be altered by going over it with a damp paint roller. This will make the glazes look uniform and smooth rather than broken up.

STEP 4

Paint the structures of the buildings respecting the edges of each façade using a range of colors that run from orange to violet and magenta and then to cadmium red.

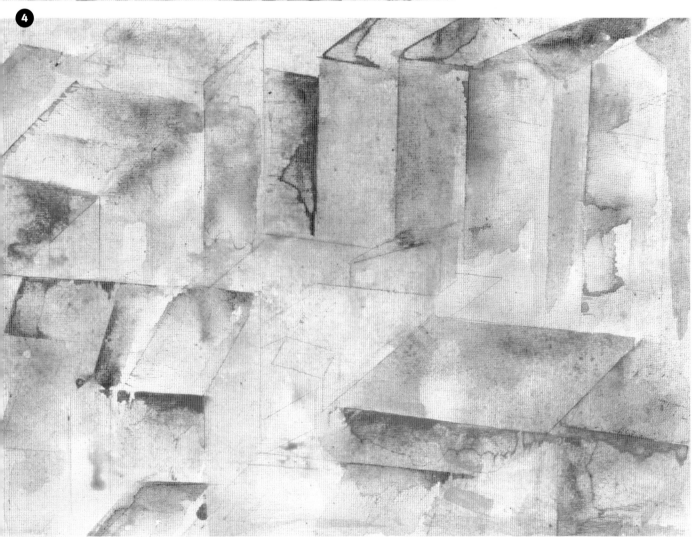

STEP 5

As soon as the support has dried, apply more glazes with blue and green to suggest the openings of the windows. Allow the acrylic layer to dry only partially before removing some of the color by wiping it with a damp brush.

Creating Structure with Glazes

The structures of the buildings are slowly constructed with thin layers of colors, synthesizing the shapes to make them abstract. The washes should not cover the painting evenly; after applying them, use a brush or a damp paint roller while they are still wet to break them up and create bare spots.

STEP 6

The tones of the painting are becoming darker as new layers of glazes are painted over the old ones. Add some lines on the rooftops, and finish the openings in the façades on the right with a gray wash.

STEP 7

Apply a general pink wash to darken the painting. At the left, add a thin layer of green paint to break the symmetry of the composition. Then lighten a few of the façades with slightly thicker paint applied with a spatula.

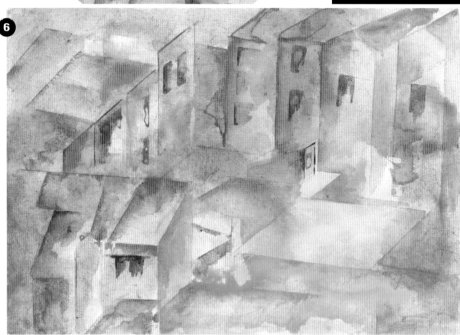

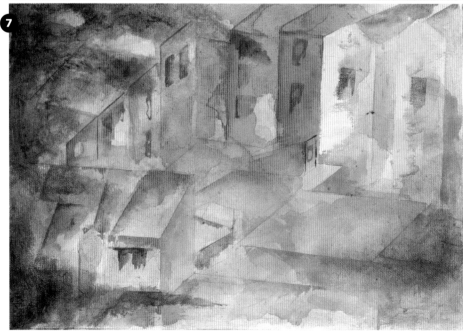

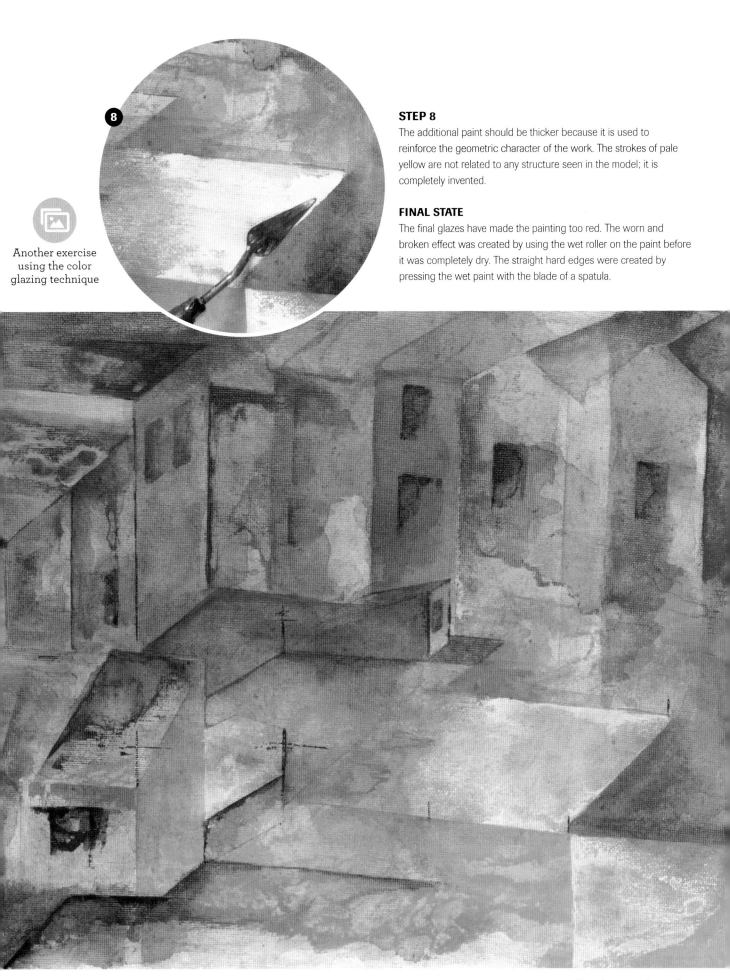

Another exercise using the color glazing technique

STEP 8

The additional paint should be thicker because it is used to reinforce the geometric character of the work. The strokes of pale yellow are not related to any structure seen in the model; it is completely invented.

FINAL STATE

The final glazes have made the painting too red. The worn and broken effect was created by using the wet roller on the paint before it was completely dry. The straight hard edges were created by pressing the wet paint with the blade of a spatula.

Using Fluorescent Colors

Acrylic paint not only comes in the full range of traditional colors but also offers fluorescent colors that are extremely luminescent and bright, as if they emanate a light of their own. Their artificial look and their use in advertising nowadays gives them a very contemporary feel. Here we offer an exercise in which it is necessary to mix some traditional acrylic colors with some fluorescent ones. The goal is to experiment with colors that you are not accustomed to, and to learn to appreciate and use their impact.

STEP 1

Use a small metal spatula to cover the head of the horse with green, orange, and magenta, all fluorescent, along with traditional blues and violets. The paint should be applied thick so that the marks of the spatula will be clearly visible.

STEP 2

The shape of the horse is too figurative; you should do some additional deconstruction to make it even more abstract. Use liquid acrylics for this, applying them with the droppers attached to the lids of the containers.

❶

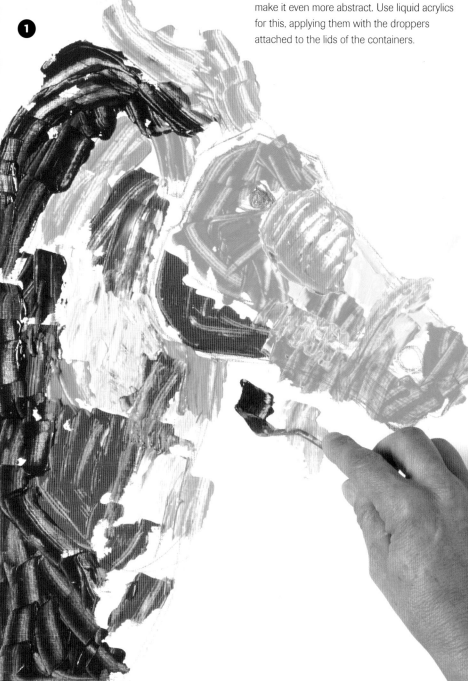

MODEL
This picture of a merry-go-round horse is an attractive subject for experimenting with a range of fluorescent colors.

Fluorescent paints are mixed on the palette in the same way as traditional paint. They can be lightened with white, which results in a tone that still maintains its luminosity and fluorescence.

FINAL STATE

The finished work has a strong visual impact; however, keep in mind that the four-color printing process is seriously limited when it comes to accurately reproducing the intensity of these colors since the printing inks are not fluorescent.

Additional images
of this exercise
so you can see
the process in
more detail

Working with Brush and Ink

Although the base of this painting was begun with applications of fluorescent paint with a spatula, the work was completed with lines that were mainly made with a brush and drips of liquid acrylics. Using a brush instead of a spatula allows you to take control of the form, better control the fusion of the colors, and more fully develop the variety of different tones that can be created with the fluorescent paint.

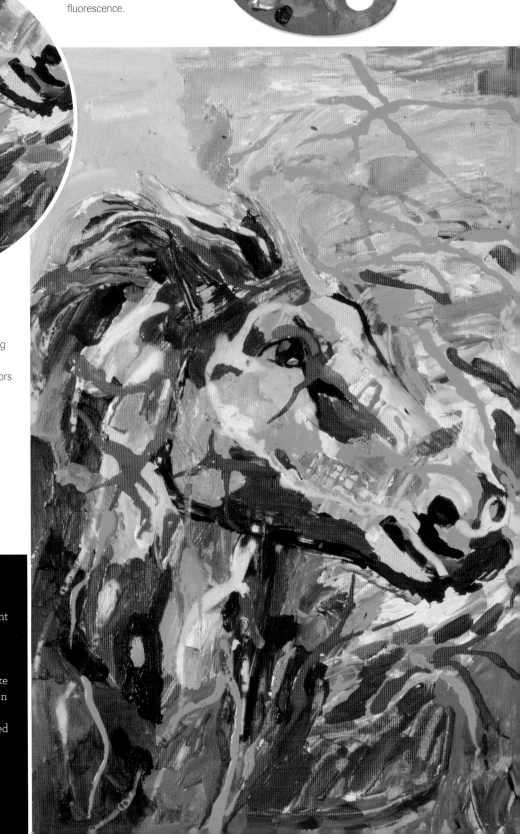

Boats with Fluorescent Colors

Painting with fluorescent acrylic paint gives you the opportunity to experiment with themes and colors that are new to you and to learn to appreciate and make use of their impact. Here we offer a very simple step-by-step exercise, an interpretation of a small group of boats in a composition with masses of striking color.

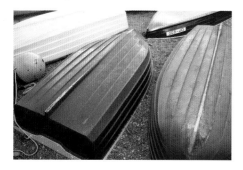

MODEL

The model consists of a group of several small boats on a sandy beach.

When working with colors that are not familiar to you, it is a good idea to start with some quick color studies.

STEP 1

The first lines should be painted directly in blue and green, and then you can go on to fill the spaces with masses of fluorescent colors lightened with white.

STEP 2

The fluorescent fuchsia can be applied after mixing with cadmium red, violet, and pink, with the goal of creating a wider range of tones.

FINAL STATE

In the finished color study you can see that the fluorescent colors have turned the model into an abstract composition, consisting of an explosion of saturated colors.

A ceramic plate makes a good improvised palette where you can combine the garish fluorescent colors with other more traditional colors.

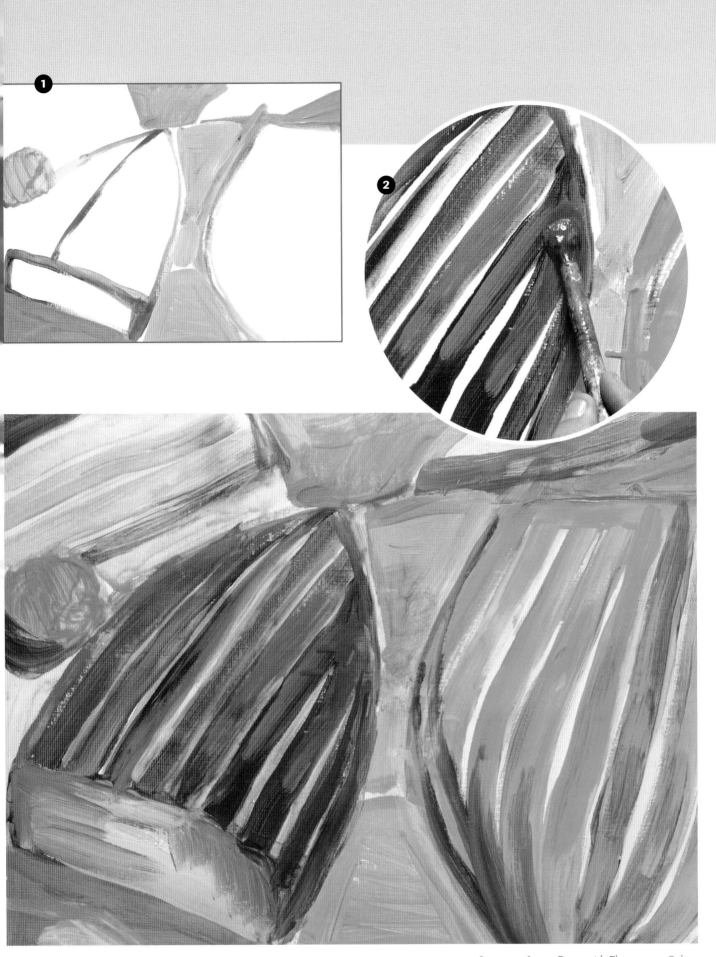

Synthesis of an Urban Scene with Colors

Inspired by the plasticity and expressivity of paint applied with spatula and brush, we continue with a cityscape. Here you will combine wide and thick strokes of paint to create very textural results; the urban elements of the city will disappear behind a blanket of streaks of thick paint that do not follow the rules of perspective nor attempt to illustrate the details of any buildings. The city only serves as a pretext for constructing a scene created by building up successive applications of acrylic and oil paint. Work with a lot of paint and without hesitation so that the first impression responds to your intuition. The technique used here combines acrylic paint with oils.

MODEL

When you observe a large city from an elevated point of view, the façades of the buildings lose detail and everything becomes an amalgam of blurred colors that lend themselves to abstraction.

1

2

STEP 1

With no previous drawing, load a brush with blue and black acrylic and sketch the river, the bridge, the near façades, and the upper outline where the sky begins. Try to capture the main forms with just a few lines.

STEP 2

Cover the surface with acrylic impasto. Apply white mixed with a dab of sienna, blue, or black, spreading them roughly with a metal spatula with a round tip.

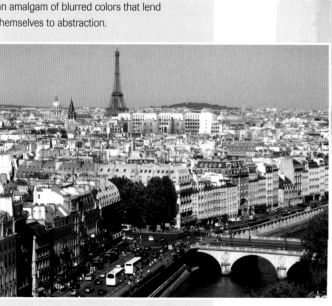

3

The spatula spreads the paint in an irregular manner in different directions. Not only can it be used to apply paint, but it can also remove paint by scraping with the edge of the blade.

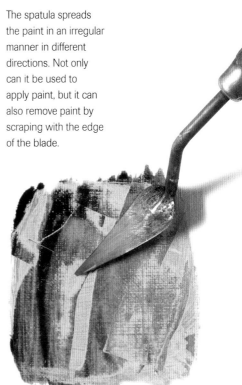

4

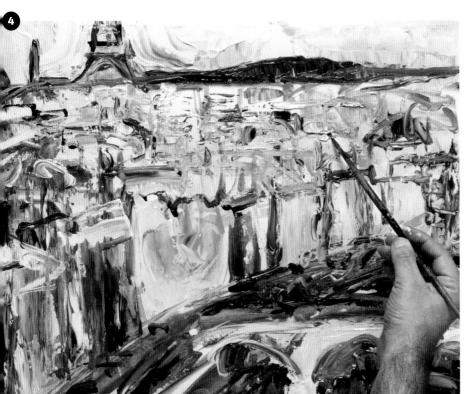

STEP 3

Now it is time to apply black, blue, and scarlet on the white surface of the impasto. The colors are mixed by simply dragging the spatula across them. The applications will be muddy and streaky creating a very expressionistic view of the city.

STEP 4

Use a brush to make black strokes in the street in the foreground and on the rooftops of some of the buildings. These gestural brushstrokes will complete your use of acrylics, now you must allow them to dry completely for a few hours.

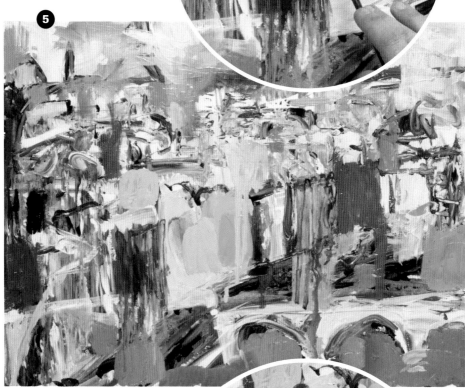

Other paintings
of abstracted
cityscapes done
in watercolor

STEP 5

Add some dripping on
the façades of some
of the buildings in the
center of the painting
with a brush charged
with diluted oils.
Lighten the upper area
so the edges of the city
are not as precise and
blend into the sky.

STEP 6

Use a brush soaked
with turpentine to
clean the channel
between each drip.
The effect will be a
slightly transparent
hatched effect.

STEP 7

The final touches will
be made with more
saturated and lively
colors. The red streaks
in the center of the
painting should be
intensified so that they
become the primary
center of attention.
Use the same color to
add some linear marks
that create graphic
interest to the painting
and add verticality to
the buildings without
making them look like
buildings.

Small Hatch Lines and Dripping

The painting has been
broken up into dynamic
strokes that fight each
other for space. The most
intense ones occupy
the middle ground,
whereas the grayish
ones cover the upper
area of the support. In
this final phase, add a
few linear details and
small hatching effects
constructed with thin
brushstrokes of oil paint.

FINAL STATE

To finish, add royal blue over the city, drawing some lines on the upper edge of the mountain, and reinforce the image of the bridge with the addition of Prussian blue, which is much darker. The final image is attractive and at the same time chaotic. Unless you have seen the original model, it would be difficult to guess what the subject of the painting is.

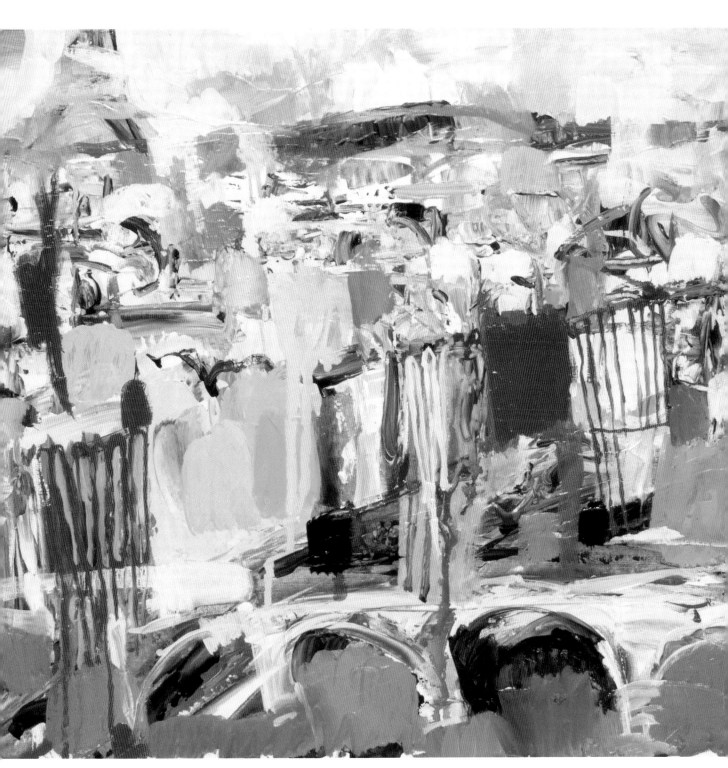

Synthesis of an Urban Scene with Colors

Some Cityscapes

This small gallery shows other approaches to abstraction based on urban subjects done in watercolor. Many of them maintain the geometric structure determined by the urban architecture, although, logically, the colors were varied, and more liberties were taken with the shapes that were painted. In some cases the link to the urban landscape is evident, but in others the final results are far from the models.

1 The model is a nocturnal landscape. At night the colors darken and the shapes become confused, which encourages an imaginative interpretation.

2 This work has a color background divided into areas of watercolors that blend with each other. The painting was finalized with several lines drawn with a reed pen.

3 In this representation, we used watercolor and lines drawn with a reed pen and India ink. The representation of an urban structure is quite clear.

3a Watercolor masking fluid was applied over a painted background. Then a wash of black ink was applied, and after it dried the masking was removed leaving very clear thick lines.

1

2

3

3a

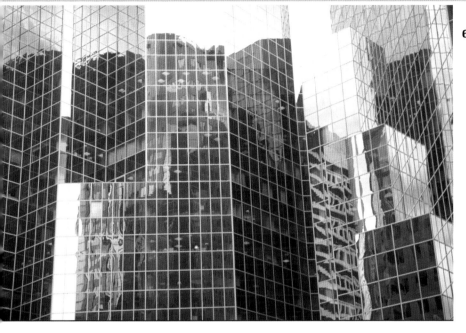

This skyscraper with the strong geometric structure of its glass curtain walls was the inspiration for the following paintings.

5 The angled grid structure of the buildings were illustrated with wide strokes of dark colors, flat bands that stand out against a background of transparent and luminous colors.

5a The streaked brushstrokes in the upper area were made by applying very little pressure with a synthetic brush.

6 This representation was based on the reflections and highlights that are seen in the windows of the building. The succession of colored brushstrokes follows a vertical progression.

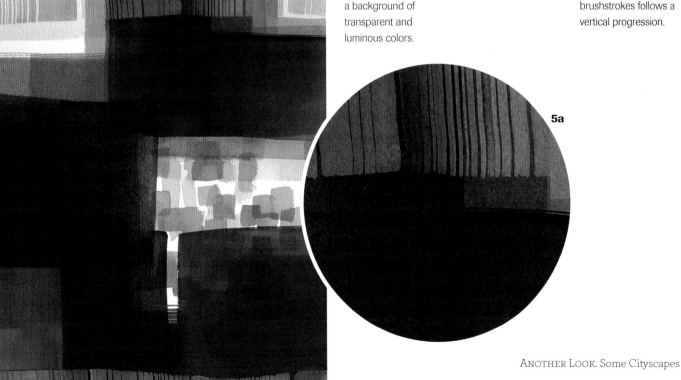

The Gestural Language of Color

I n an abstract painting, the colors can be blended and mixed to the point that they are completely removed from the tyranny of form. The outlines disappear, and the composition becomes a field of different colors that interact with each other in a fluid and almost atmospheric way. The surface of the painting fills with long brushstrokes going in different directions that are activated as if they were the result of a continuous ruckus. This exercise is about empowering the colors, completely disconnecting them from form. The step-by-step exercise is inspired by a real image, but the result is completely free of any figurative reference. You will use oil paint, which will sometimes be applied with a brush and at others with a metal spatula.

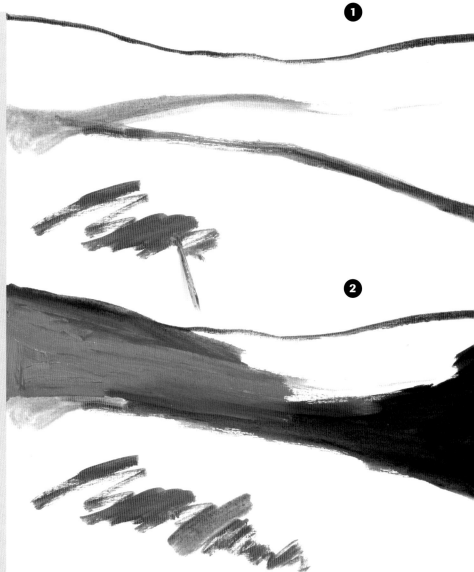

MODEL
The starting point is a view of the interior of an extinct volcano. The warm, changing colors on the ground should be present in the abstract work.

STEP 1
The model is so simple that no preliminary drawing is required, just draw the outline of the volcano with cadmium red diluted with turpentine. These first strokes, which should be made quickly, will later be hidden underneath the first layers of paint.

STEP 2
Use thick paint to cover the middle area of the painting, making a mixture of Prussian blue and cyan. The paint should be applied heavily so that the brush glides easily across the support.

STEP 3
Continue in the same way on the lower part of the canvas, but this time blend the yellow and cadmium red with quick strokes of the brush. The brush marks should be clearly visible. Be careful at the edges o the areas; do not allow the brush to touch the still wet blue paint.

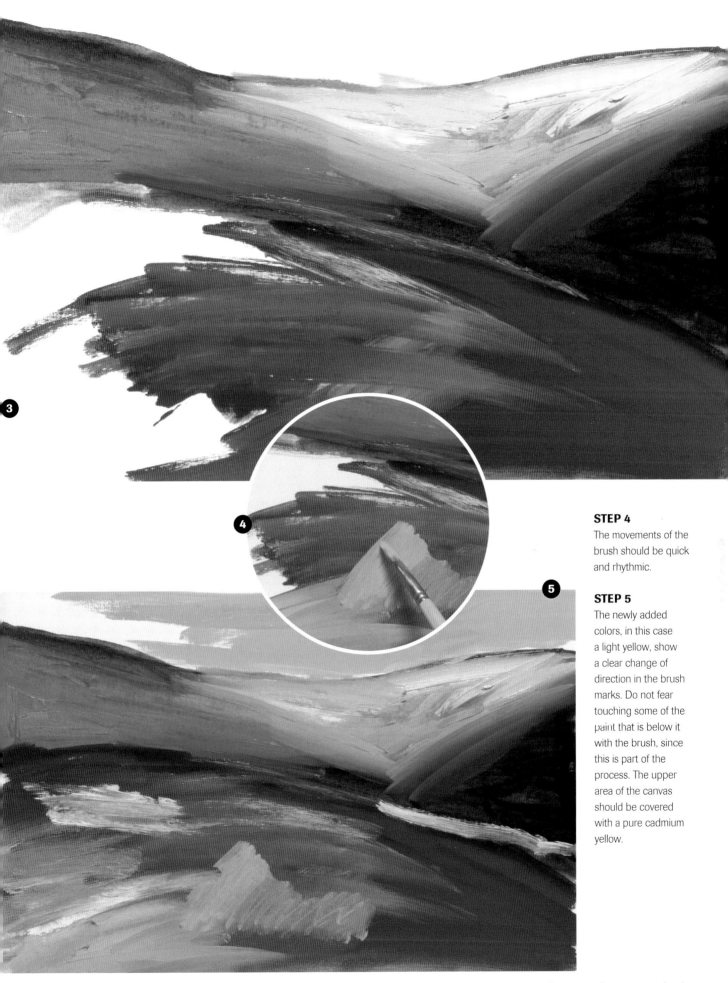

STEP 4
The movements of the brush should be quick and rhythmic.

STEP 5
The newly added colors, in this case a light yellow, show a clear change of direction in the brush marks. Do not fear touching some of the paint that is below it with the brush, since this is part of the process. The upper area of the canvas should be covered with a pure cadmium yellow.

STEP 6

Take a metal spatula and drag it, completely flat, across the layer of wet paint to create more broken streaks and a sort of blurring effect between the different orange shades.

STEP 7

Put some titanium white on the back side of the metal spatula blade and apply it in certain parts of the composition, going over them repeatedly to blend them with the wet paint. They should not be distributed in a balanced manner; you must make sure that the image does not become symmetrical.

STEP 8

Use the thin edge of the spatula blade to blur the edges of each one of the main areas of color, so that the colors run into the adjacent areas. The painting now looks like a landscape dissolving into great masses of steam.

STEP 9

The final touches should be made with thick saturated color in the center of the painting, creating a focal point, a center of attention that attracts the attention of the viewer.

Another interpretation
of this same exercise

Developing an Intuitive Painting

As you make progress, you should forget about the reference model. In addition, the colors should not be related to it at all. You must develop a much more intuitive painting, inspired by your taste and where you want to take it. Little by little the brushstrokes will become more meaningful, and the physical limits between the main areas of color will disappear.

❾

FINAL STATE

The original model has changed into a passionate painting where the colors and their energy are the absolute protagonists. There is no room for drawing, lines, or any figurative reference. The bands of color are pure energy that makes no reference to the model, which seems to have been completely forgotten.

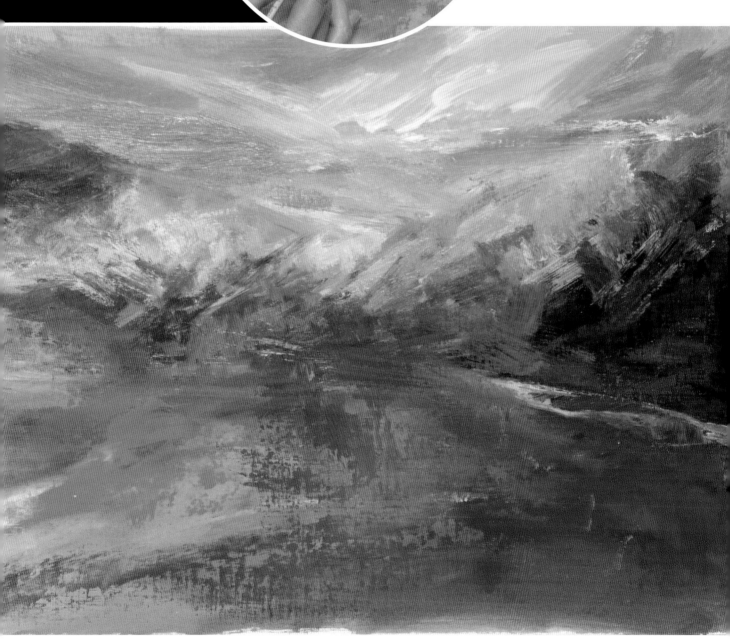

Finding Inspiration in Children's Paintings

Abstract art attempts to communicate something through the use of colors and lines that are full of expressive force. An abstract painting can tell a story or transmit a feeling through color. Sometimes artists think they can express themselves using colors where the forms of a body that are vaguely sketched dissolve into areas of color. In this step-by-step exercise, you will create a work with an aggressive and provocative feeling. In it you will combine the intensity of the colors with the thick paint of the German Expressionists. More important, however, are spontaneity, imprecision, and simplicity linked to the infantile. The way the paint is applied and the imprecise details are inspired by the drawings and paintings made by very young children. You will be using a combination of acrylic paint and oils.

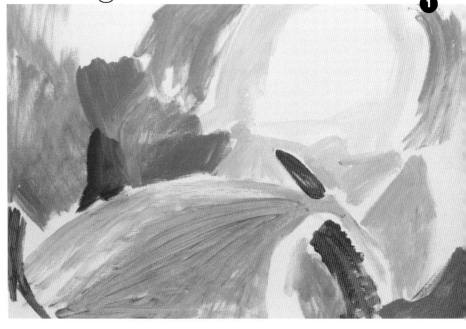

STEP 1

A preliminary drawing is not necessary. Begin painting the support with diluted acrylics, first imitating the approximate colors of the model, but in a very stylized manner.

STEP 2

The paint should be applied with short rhythmic brushstrokes, combined with lines and other more gestural strokes. The quick-drying acrylics will keep the colors from mixing uncontrollably and becoming muddy.

MODEL

Since the exercise is inspired by drawings and paintings by children, we have chosen a few-months-old baby as the model.

When you are working with colors, your palette should have a good selection of pure acrylic colors for the first phase of the painting.

2

FINAL STATE

The result is an active painting that creates the illusion of movement. Masses of colors are placed next to each other without following any apparent rules; they are applied with brush and spatula, one layer over the next. The human figure that inspired the exercise fades away and is barely recognizable in this dramatic situation.

More images of this subject so you can closely examine the step-by-step process

The Ingenuousness of Children's Art

Strong, bright colors, along with strokes that are built up over each other and become disconcerting, make for a dynamic and attractive painting. Hesitant brushstrokes and imprecise faltering shapes and outlines will give the piece an ingenuousness and purity that is characteristic of children's artwork.

Scribbling and Building Up Lines

The need to experiment with colors and fill the surface of the support with a dense amalgam of lines is usually one of the characteristics of the first artistic explorations of children, the pure pleasure of drawing a line for its own sake, following the rhythmic motions of the forearm.

2a Construct grids of colors with oil pastels on the lower layers that later can be partially diluted with a brush soaked in turpentine.

2b The darkest black lines should be made with a fat oil pastel stick, which will have a consistency that is very similar to an impasto made with oil paint.

2c Cover all the lines made with oil pastels with a grid of thick strokes of oil paint that has been mixed with a little Holland varnish to make it flow better.

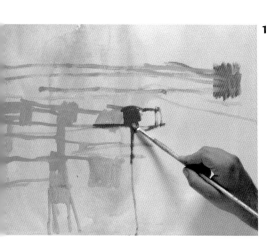

1

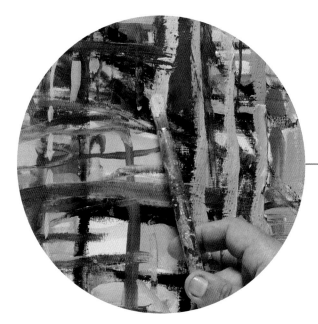

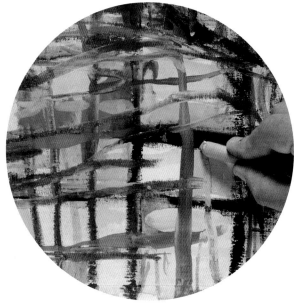

2

1 Before starting to overlay dense brushstrokes, it is a good idea to prepare the background with diluted oils and a few applications of somewhat liquid colors. These first colors will be interwoven with the brushstrokes.

2 The brushstrokes of thick dense oil paint should completely cover the surface of the painting, barely leaving any unpainted spaces. This is an exercise of pure abstraction, and there is no model or figurative reference to follow.

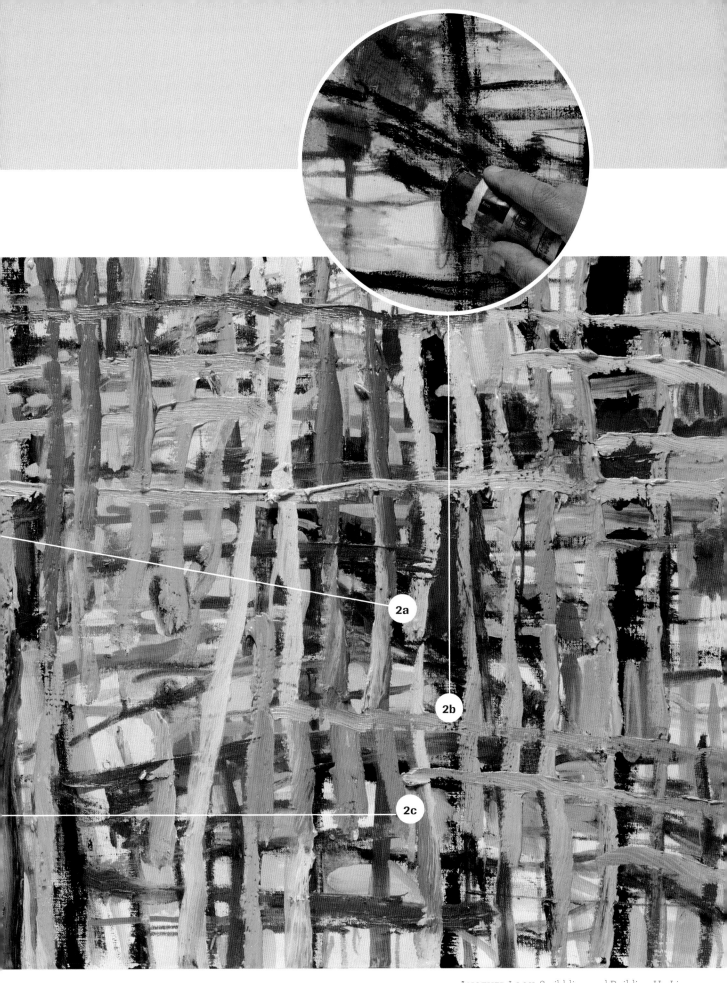

2a

2b

2c

Synthesizing with Fluorescent Colors

In this gallery, we exhibit a group of works that are the results of experimentation with fluorescent and iridescent colors and variations inspired by the synthesis of geometric shapes. The main approach used by this group was based on studying the composition, knowing how to distribute the shapes and colors in an attractive way that enhances the textures as well as the chromatic vibrations caused by the contrast between the traditional acrylics and the range of the atypical fluorescent ones.

1 Paint a base with the recently developed gray- and gold-colored metallic paints, and then spread fluorescent colors over them with a flat spatula. The cross is a compositional theme that always works.

2 Here is another version that is more stylized, with only three colors: fluorescent red, interference green, and iridescent iron gray. Each color has a different amount of fluidity so that the painting is not too flat and monotonous.

3 In this composition, the artist used warm iridescent tones like gold, copper, and bronze, as well as pure white and pearl white mixed with a touch of turquoise blue. The upper bands of color were quite fluid when applied, whereas the layer of white looks pasty and more textured.

1

2

4 The compositional basis of these works is the quartering of the image with rectangular shapes, each of them defined with different colors and painting techniques. The fluorescent red here was mixed with a little sienna and white to reduce its intensity.

5 The background of the painting is covered with very subtle gray tones, mixed with a silver color, iron gray, and interference blue. The colors appear to be blended with each other, except in the center, where bands of fluorescent red and iron gray were applied with a wide brush that left visible streaks.

In the previous chapters, we have shown some of the approaches for adding texture to the paint—using impastos, applying paint with a spatula, and employing paper collages. The lack of exactitude and certainty that is typical in abstract painting is an advantage when you are confronting daring and expressive themes where texture is the protagonist. Fillers or additives like marble dust, sand, gesso, mica, carborundam, pumice, and various homemade preparations are often used for texture. The technique we propose is direct modeling, creating the relief on the surface before painting it. This way you can create a rough surface to paint on to create different shades, to add a tactile sense, and even to incorporate real shadows in the painting. Everything is aimed at creating a stronger visual impact and expressiveness. We offer several approaches in this chapter, so you will have available more resources and techniques to create various textures and abrasives that will add a new dimension to your abstract work.

Impasto as a Means of Synthesis

In this first exercise, striking with the brush and the hard-edged spatula combine to create an exuberant strength in the material that will later be tamed by refined tones, different variations of light blue that fit in very naturally. The goal is to break down the image by creating a dense grid of impasto with a lively, bold, and unrepentant style. The spatula work is striking and very visible, converting the texture into the main protagonist of the work. It will be metamorphosed by the action of the luminous colors that communicate a strong harmony. In this step-by-step exercise, you will combine white modeling paste with oil paint.

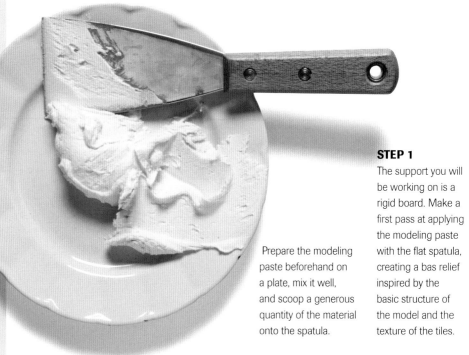

Prepare the modeling paste beforehand on a plate, mix it well, and scoop a generous quantity of the material onto the spatula.

STEP 1

The support you will be working on is a rigid board. Make a first pass at applying the modeling paste with the flat spatula, creating a bas relief inspired by the basic structure of the model and the texture of the tiles.

MODEL

This tightly framed picture of some rooftops is the source of inspiration for this exercise. The roughness of the slate tiles will be the inspiration for creating textures.

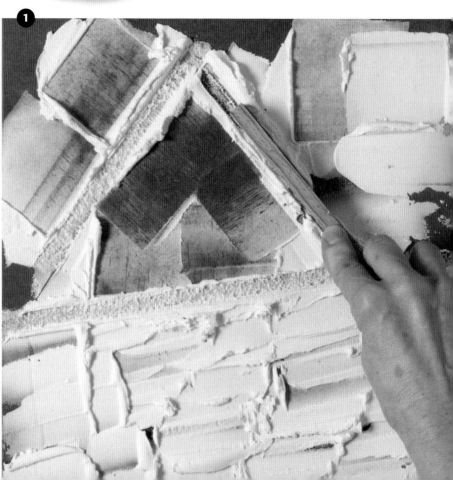

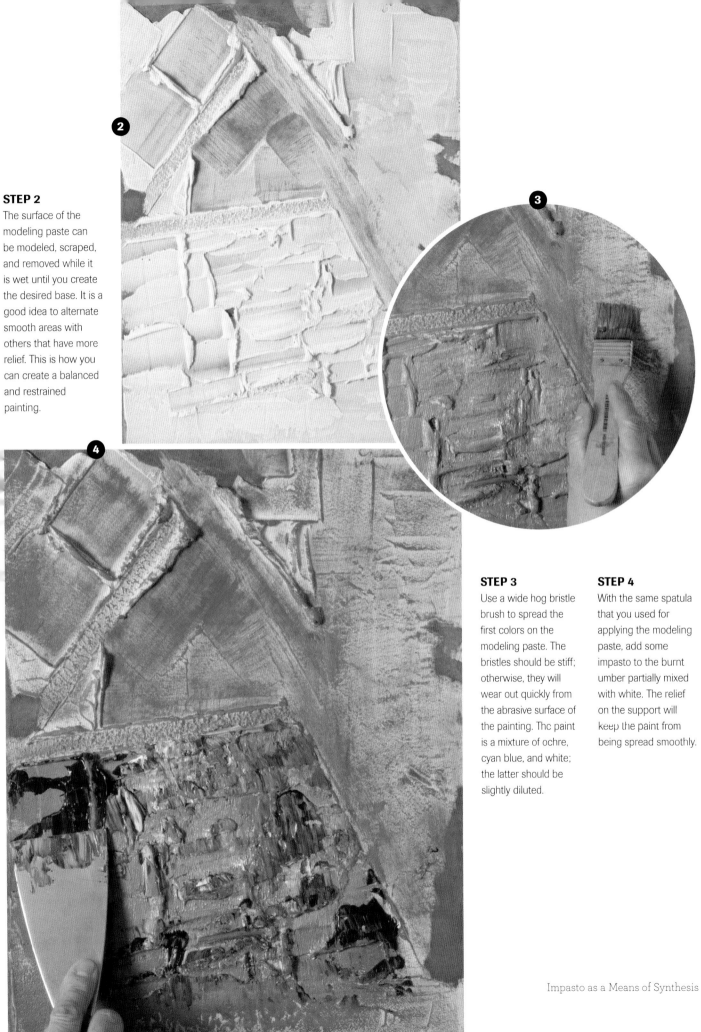

STEP 2

The surface of the modeling paste can be modeled, scraped, and removed while it is wet until you create the desired base. It is a good idea to alternate smooth areas with others that have more relief. This is how you can create a balanced and restrained painting.

STEP 3

Use a wide hog bristle brush to spread the first colors on the modeling paste. The bristles should be stiff; otherwise, they will wear out quickly from the abrasive surface of the painting. The paint is a mixture of ochre, cyan blue, and white; the latter should be slightly diluted.

STEP 4

With the same spatula that you used for applying the modeling paste, add some impasto to the burnt umber partially mixed with white. The relief on the support will keep the paint from being spread smoothly.

Impasto as a Means of Synthesis

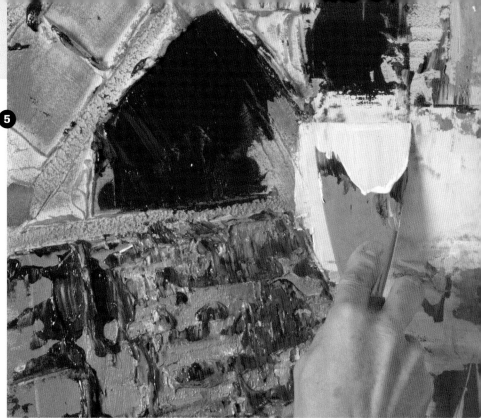

Creating Structure with Colors

Construct the main zones of color on the textured base. The style should be forward and alive and not show any signs of hesitation; everything should be executed quickly, applying acrylic paint with the spatula. The spatula should be dragged purposefully to produce a color with mixed streaks of paint. The distribution of the masses of color synthesize the model in rectangular geometric units.

STEP 5

Do the same thing in the areas where modeling paste was not applied; here, the oil is easier to spread, and it forms a film of smooth paint that clearly contrasts with the adjacent areas where the paint is fragmented.

STEP 6

You do not have to work quickly with oil paint. Drag some cyan and cobalt blue over the wet surface of the yellow paint. The blending of these colors produces green mixtures.

STEP 7

Continue covering the spaces at the top of the painting with additional impastos. It is helpful to turn the board to find the best position for working with the spatula, which you should drag several times over the paint to create a smooth but slightly striated surface.

The artist should have a collection of spatulas of different shapes and sizes, as well as other tools that can be used for applying modeling paste, thick paint, and even scraping and making sgrafitto.

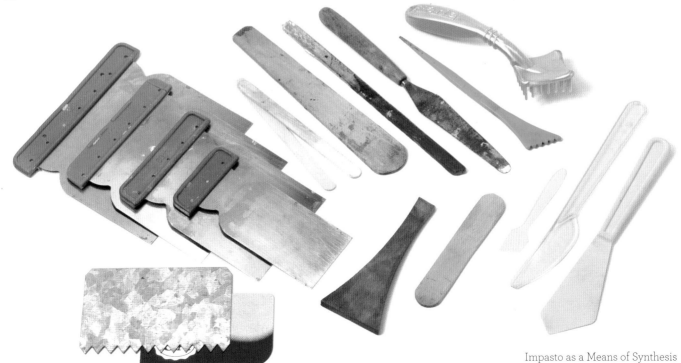

Impasto as a Means of Synthesis

Reducing the Saturation

The surface of the painting is covered with blue, green, brown, and light yellow impastos, although the dominant color is blue. The colors are barely mixed, having been applied straight from the tube and saturated. When all is finished, the final look of the painting can be harmonized and the saturation reduced by applying a white glaze that will give the painting more light and reduce the contrast between the colors.

STEP 10
Before undertaking the final whitening phase, allow the oil impastos to dry for more than a week. Charge a hog bristle brush with white diluted with a little Holland varnish, and apply it over the blue paint to create a light glaze.

FINAL STATE
The last translucent layer of titanium white completely changed the look of the painting. The aggressiveness of the impastos is softened by a new range of colors that give the work a much more harmonious and pleasant mood.

STEP 8
Each time paint is applied, it is thicker and at the same time the size of the spatula is smaller. The painting is dominated by light blues and other darker and more violet blues, disturbed only by some light yellow and burnt umber colors.

STEP 9
Put one or several colors roughly mixed on the palette on the bottom of the spatula blade, and apply them with a little pressure and a quick dragging motion.

Another exercise done with impasto

Impasto as a Means of Synthesis

Scratching and Scraping the Paint

To make an abstract painting, it is helpful to be aware of many techniques so that you can use them at the opportune moment. Several techniques often coexist very discreetly in a single work of art. This exercise is a good example: applying sgrafitto on a base of heavy impasto similar to the one in the previous step-by-step exercise. It consists of removing some of the layers of material from the surface of the painting before it dries. In this operation, you will use metal spatulas, toothed spatulas, and other pointed tools that will determine the width and depth of the sgrafitto. This will be a mixed media piece with the addition of diluted oil paint.

MODEL

An ancient leather tannery where the wells resemble the cavities in a beehive and add a rhythmic feeling to the composition.

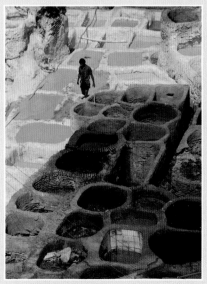

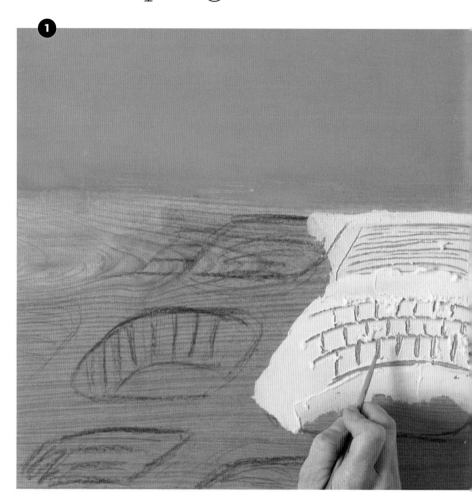

STEP 1

The base of the work will be a Formica board on which you will make a preliminary drawing with blue crayon. Cover some of the background with orange oil paint using a palette knife. Then spread modeling paste and scratch into it with a simple plastic point.

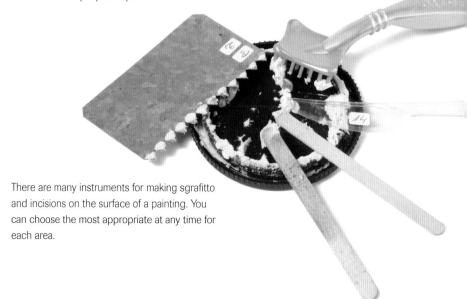

There are many instruments for making sgrafitto and incisions on the surface of a painting. You can choose the most appropriate at any time for each area.

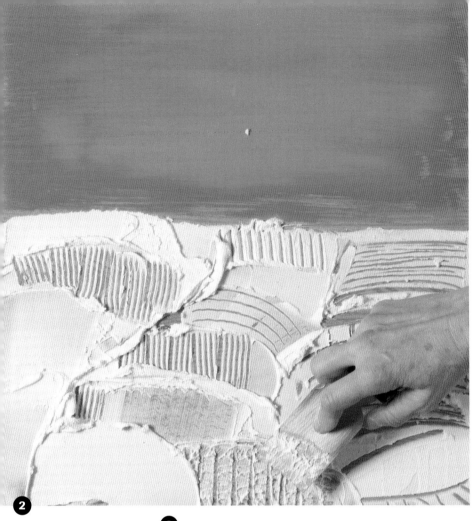

STEP 4

Use the flat spatula to apply fine grain modeling paste on the upper area of the painting. Before it dries, make some new sgrafitto images with a wood spatula, trying to reproduce the elliptical shapes in the model.

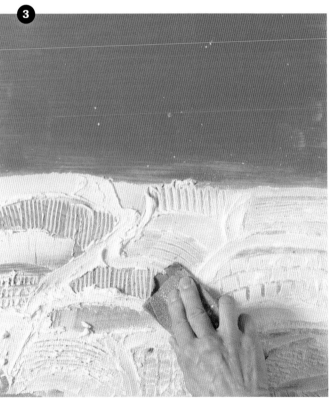

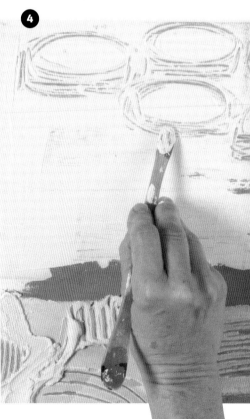

STEP 2

Alternate the use of spatulas and other objects to create a variety of sgrafitto marks: parallel hatch lines, wide striking incisions, and textural effects made with a flat spatula.

STEP 3

Allow the modeling paste to dry for two or three hours. When everything has hardened use a piece of medium grain sandpaper to polish the surface. The goal is to reduce the abrasiveness and prepare the surface for painting with a brush.

STEP 5

The process of adding color should be done with oil diluted with a lot of turpentine that will easily tint the whitish color of the modeling paste. You must use a hog bristle brush so it will not wear out.

STEP 6

The diluted oil paint puddles inside the grooves. Allow it to dry a little, so that the turpentine evaporates, before adding a new layer of color.

STEP 7

While the paint is still wet, rub the textured surface with a thick absorbent rag to remove some of the color and make the surface look more worn. Repeat this on the upper area of the painting, but since this part is less abrasive, you can wipe it with a synthetic sponge.

FINAL STATE

To finish, add some additional whitish impastos on the upper half of the painting, which will have turned grayish from the rag soaked with diluted paint. You only need to rub it so that the layer of modeling paste absorbs some of the paint and matches this dominant gray.

Other examples of sgrafitto

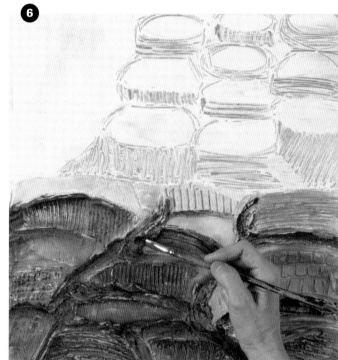

Very Diluted Paint

Before attempting the final phase of the painting, which is the quickest and simplest, make sure that all the filler material used for modeling on the surface of the support is completely dry and well sanded. From here on, the oil colors will be very diluted with turpentine rather than applied as impastos; the goal is for the liquefied paint to flow into the textures and accumulate inside the sgrafitto marks.

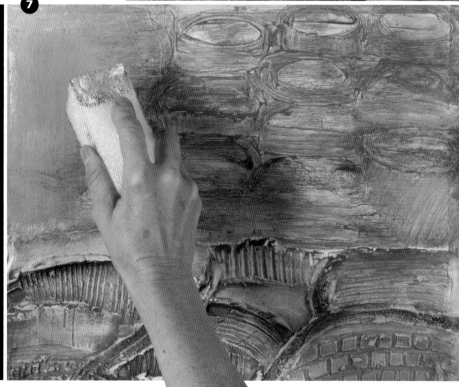

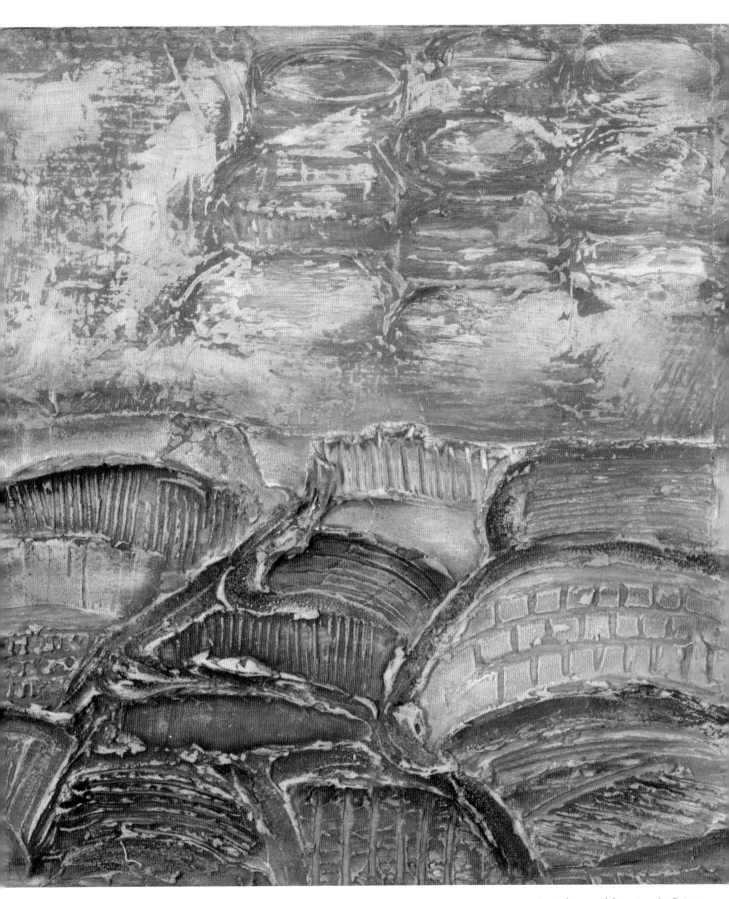

Scratching and Scraping the Paint

Diluted Paint over Gesso

When a color wash or watery paint is applied over a surface textured with gesso or modeling paste, the application tends to emphasize the relief on the surface and cause it to stand out. The diluted paint accumulates and is deposited in the cracks and fissures, forming puddles that highlight the texture when they dry.

3 The texture of this abstract composition was previously created with gesso. Impastos were applied with a spatula and then sgrafitto marks and lines were made on the surface.

3a To apply a second layer of color, here an orange tone over blue washes, it is advisable to wait a little as the first diluted color dries.

3b The grooves are sgrafitto lines made with the round tip of a metal spatula.

3c If you look closely at the surface, you will see that the diluted paint pools in the lines and grooves and emphasizes the texture of the gesso.

1 Newsprint soaked with latex is a good alternative to textures made with gesso. In this case, the wrinkled paper is covered with a layer of glue with a fine grain sand filler.

2 You can cut the paper into small pieces and soak them in white glue until they form a relief paste that can even be applied with a brush.

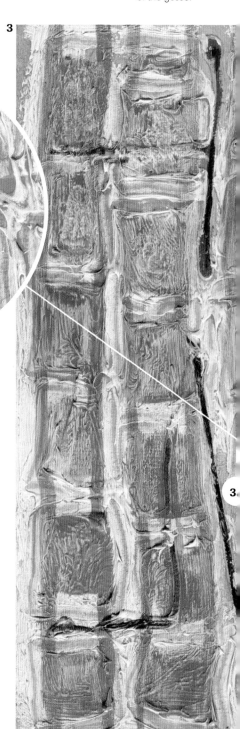

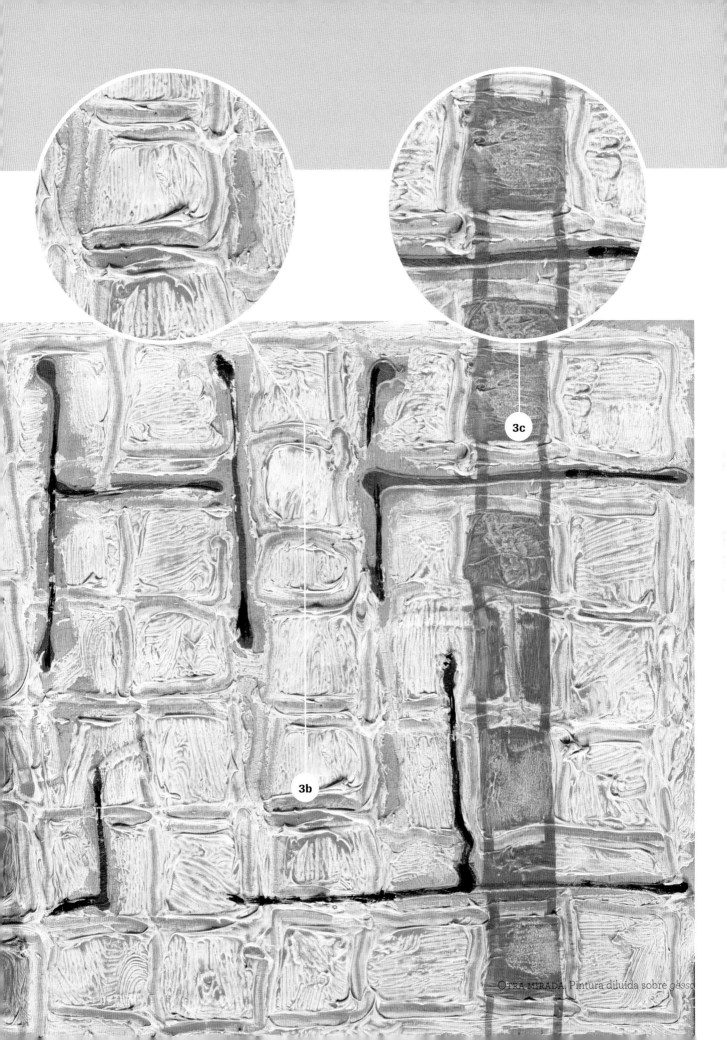

3c

3b

OTRA MIRADA. Pintura diluida sobre gesso

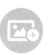

A Compositional Approach to Collage

The following step-by-step exercise will transform an architectural scene into an abstract work where the brushstrokes of oil interact with a previously planned color base. Collage creates a very interesting colored surface on which to work; it is very different from the traditional white background of a canvas. The graphic contrast between these two languages creates a very attractive plastic effect. Laying out the model with cutouts of colored paper not only is an interesting exercise in synthesis but also supplies good training in composition because it is not a matter of haphazardly gluing down colored papers. You must compose with them so that the final result looks attractive and convincing.

MODEL

The contemporary architecture in large cities offers unique models for creating abstractions. Many of them are abstract compositions themselves.

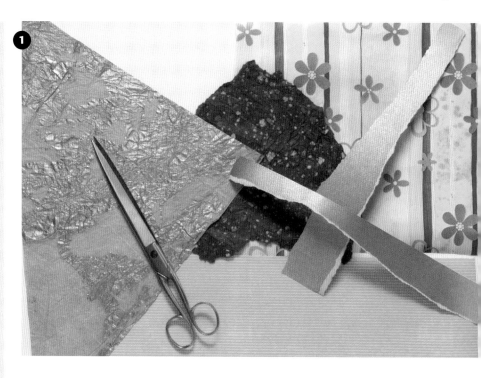

STEP 1

You do not have to settle for just one type of paper; you can combine several different types of paper, even if they are wrinkled and even printed, to create diverse colors and textures.

STEP 2

When you plan a collage with papers, it is very important to decide whether they will be cut with scissors or torn by hand, since the contrast between the edges of cut paper and torn paper can greatly affect the concept of the work. In this case, you will combine both options.

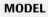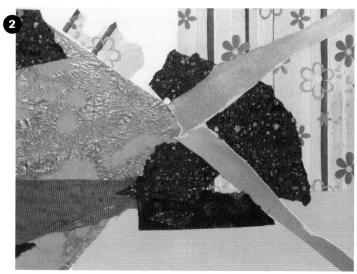

3

STEP 3

The model should be interpreted quite freely. For now, hatch lines of different contrasting colors fill the middle ground of the painting. The choice of each color depends on the paper that will be underneath, since it has to contrast quite a bit.

FINAL STATE

The architectural grouping is finally completely broken up, hidden underneath an amalgam of colorful brush lines that (depending on how you see them) converge on or spring from the center of the painting. The paper background interacts with them, showing through the brushstrokes to create a counterpoint that is more restrained than the explosion of color in the oil painting.

More images for
you to see the
step-by-step process
in greater detail

A Color Approach to Collage

1

Collage makes an interesting surface on which to work, very removed from the traditional white background. You must be able to combine different colors and types of paper, to create vivid contrasts that will become the base for an abstract composition. The conjunction of two languages, the large areas of color created by the papers, and the more emphatic linear structures, are the key to the representation in this painting.

1 When choosing the papers, you must pay close attention to the colors and try to create a harmonious group rather than choosing randomly contrasting colors.

2 Torn paper is more accidental, expressive, suggestive, and organic.

3 Glued paper with cut edges suggests a more solid and decisive structure.

2　　**3**

4

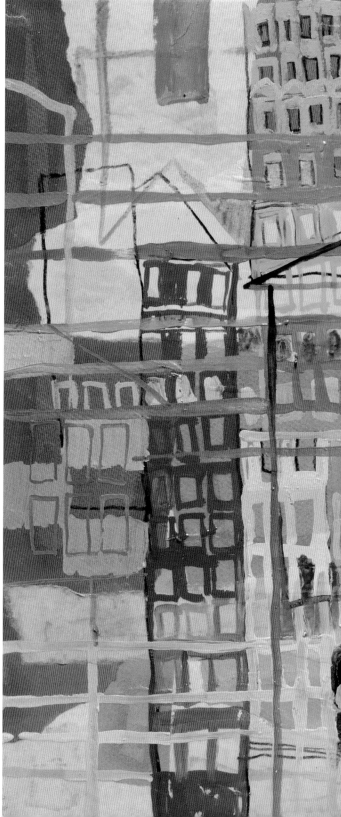

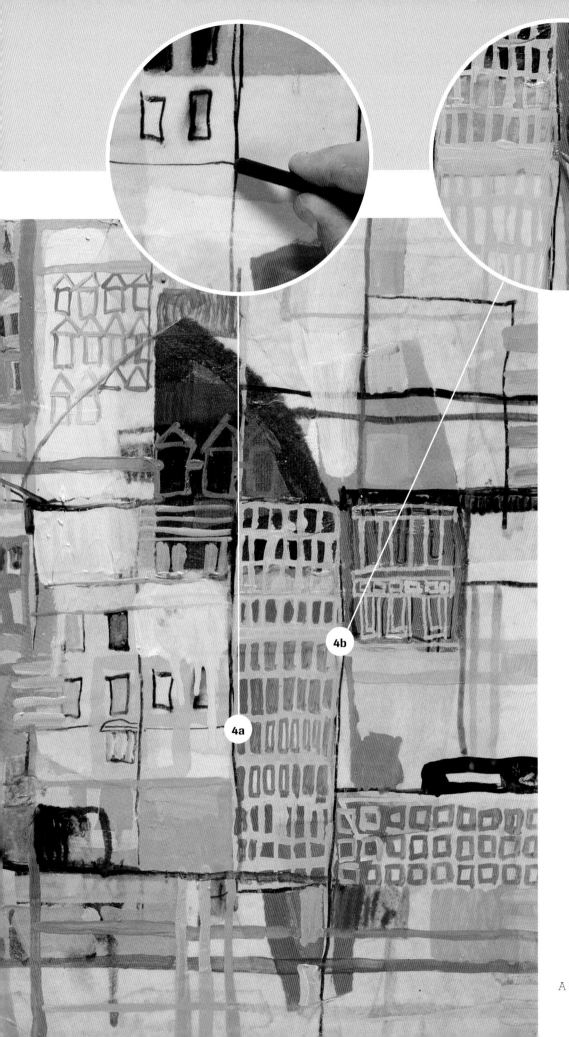

4 The final result is a somewhat frenetic representation of brushstrokes and lines that were inspired by a group of building façades.

4a The thinnest lines were made by applying a lot of pressure to a black Conté crayon to make the lines very dark.

4b The pencil lines are completed with the addition of oil paint, making hatch lines with a strong geometric tendency.

A Color Approach to Collage

Landscape with Fillers for Texture

I t is obvious that the incorporation of fillers to add texture plays an important part in abstract painting. Since the painting of abstracts has moved further from the figurative representation of the model, there is a need to compensate with visual stimuli to create interest on the part of the viewer, and it is often done by emphasizing the surface treatment of the painting. In this approach, the essence of the painting itself is accentuated by manipulating the medium, as if the paint itself contains an intrinsic force rather than being merely an instrument that describes the reality of its surroundings. In the cases where relief is created in the painting by adding a filler, it becomes an end in itself, not just a vehicle of expression. In this step-by-step exercise, you will mix acrylics with modeling paste that has a fine grain filler. Only media with strong agglutinates like oils and acrylics are able to carry fillers of this kind.

MODEL

Here is a rock with an interesting form. These kinds of models lend themselves to abstraction and do not require the artist to change them very much.

STEP 1

The base for the painting is a plywood board covered with a layer of ultramarine blue paint. The paint should be thick and heavily applied. Allow the acrylic to dry completely before going any further.

STEP 2

Over this dry coat, use a white pencil to sketch the shape of the rock. The hole or opening and the horizon line can be made by reserving them with pieces of masking tape.

Fillers are solid materials that create relief, adding noticeable texture while barely altering the color. Stir the mixture well with a spatula to distribute the filler throughout the paint.

STEP 3

Prepare a large amount of modeling paste and mix it with a little acrylic paint. Spread it with a metal spatula, making several diagonal strokes. While the paste is still wet, remove the masking tape from inside the hole.

STEP 4

Paint the sea with a layer of homogenous black paint, and then remove the strip of tape; the result will be a very straight line. Then add some more paint with the spatula to the lower area, making short streaks of black, sienna, and yellow.

STEP 5

Allow the painting to dry for several hours, until the paint is hard. Use a sheet of medium grain sandpaper to rub the lower area, causing it to wear away and to make it smoother for the paint brush.

Balancing the Painting

Use a brush or a cotton rag to wipe off the dust you created by sanding. Because of the sanding, the colors will look lighter than when they were applied, with a grayish tendency that will give the work a more homogenous feeling. You only have to add some details to the composition, for example introducing a circle of color in the upper right corner; this will compensate for the large mass of red color and fill a void that could throw the work out of balance.

STEP 6
Evaluate the possibility of placing a circular shape in the upper corner of the painting. To avoid getting paint on the support, make a couple of circles on a piece of transparent acetate and try them by holding them over the area to test the results.

STEP 7
Since incorporating the round shape does improve the composition, mix a little acrylic paint with modeling paste and spread it with a spatula very carefully, making a circular motion with the blade.

STEP 8
The modeling paste must be worked slowly. Allow this latest application to dry before sanding its surface to equalize the effect with the rest of the painting.

Another approach where the paste is applied with a spatula

FINAL STATE
Clean the traces of dust with a damp sponge so that the surface of the painting is very clean. To finish, apply some brushstrokes of a slightly more intense blue over the layer of paint around the circle. The process has been quite simple, and the final result is without a doubt sensational.

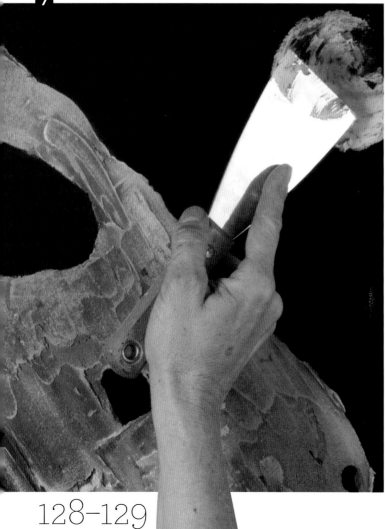

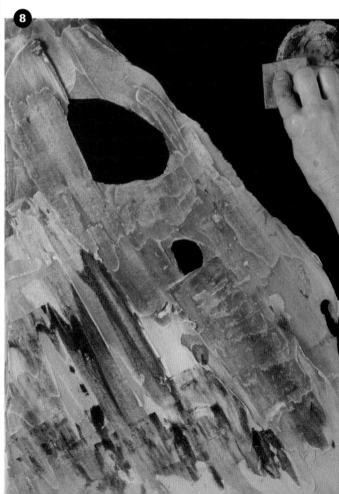

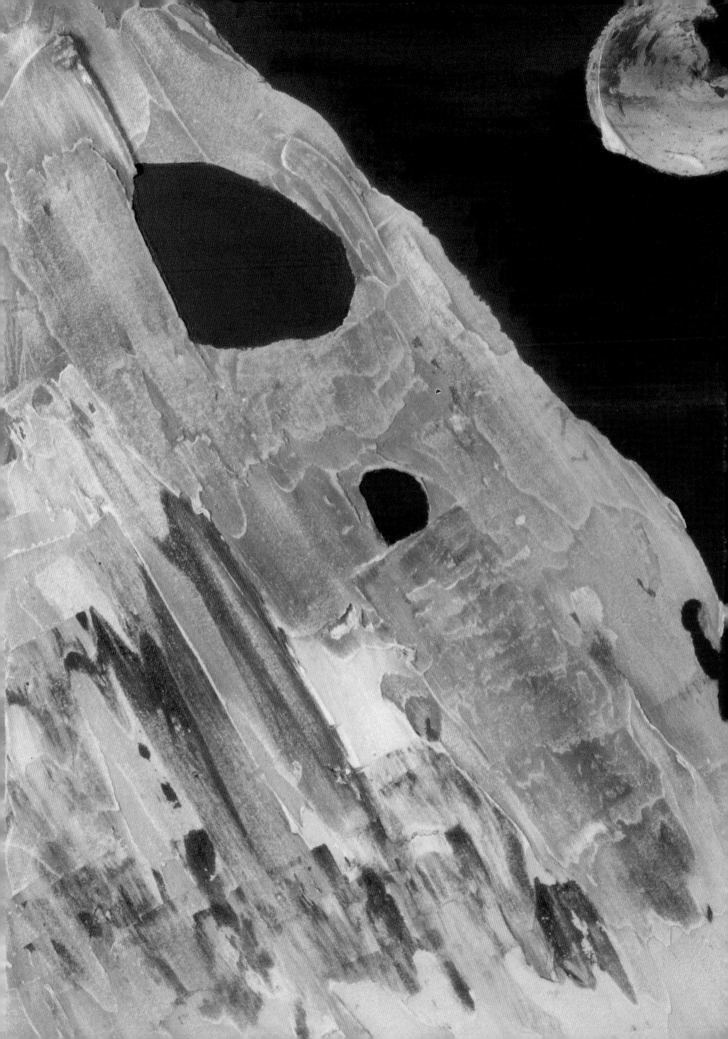

Textures and Added Materials

Here we display some other approaches where the texture and the objects incorporated into the surface of the painting become the protagonists of the work of art. You will observe different results depending on the amount of modeling paste used (since the weight and volume of the paint will vary) and on the grain size of the filler in the paste. The modeling paste is very adhesive, and it also allows you to incorporate three-dimensional bodies or objects that add texture and volume. This gallery demonstrates how you can work with the paint, apply the modeling paste, integrate it into the work, and paint it to strengthen the relief effects.

1 The dynamic feeling of this painting mainly comes from the irregularity and variety of its textures. After preparing a base with modeling paste, some incisions were made and some sgrafitto lines were added to activate the upper half of the canvas. Then these effects were strengthened by adding the colors.

2 A fine-grain filler was used in the upper area, so that the resulting texture would be smoother, despite the grooves. The adhesive strength of the modeling paste was exploited to add a piece of rusty sheet metal to the support. Its aged look gives the work a painterly look.

1
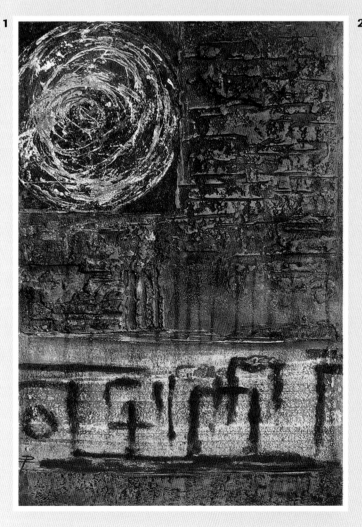

2
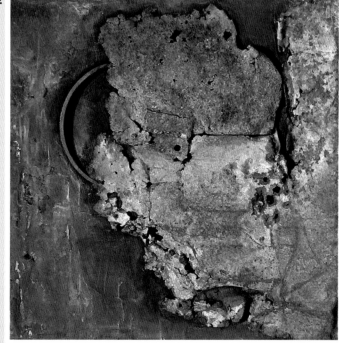

3 Here we added a piece of rusted metal to a base prepared with latex and a medium-grain filler. Then, it was painted with diluted oils to tone down the contrasts between the different surfaces, which are very well integrated with brushstrokes of varied intensities.

4 In some paintings the texture is everything. The use of oxidized surfaces combined with washes, impastos, brushstrokes, and colors respond to a sensitive plastic universe where all recognizable elements disappear.

5 This representation was made with a marble dust filler. You can see the granulated effect in it. The thickness of the texture creates shadows on the surface of the painting that add drama to the work. Here the abstraction is created by taking the objects to a high level of synthesis or stylization.

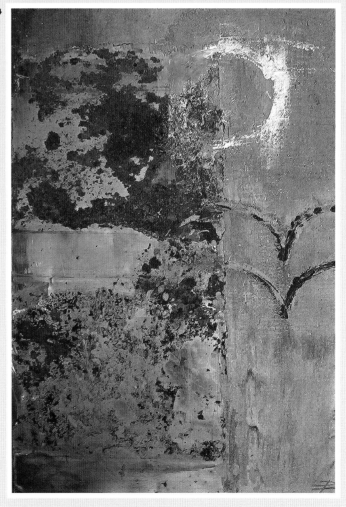

Experimenting with Wax Glazes

For the final exercise we propose an aquatic model, a group of fish in a pond. The intention is to work on different interpretations of this same model using a common medium in all of them: paraffin or wax as the finish on the painting. The wax can be applied transparent, slightly white, or even as an impasto to create glazes that dilute the shapes and create a finish that is more blurred and partial than a simple figurative representation of the fish. Incorporating new techniques and media is an important part of abstract interpretations because they add variety to the work of art.

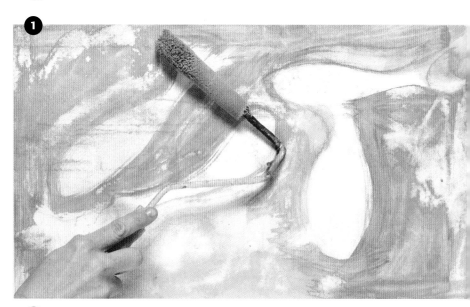

MODEL

The source of inspiration for this interpretive exercise with wax glazes is a school of carp that swim slowly and rhythmically in a pond.

STEP 1

Paint the background of the pond with green acrylic, reserving the white shapes of the fish. After the paint has partially dried, go over it with a damp roller.

STEP 2

Let the layer of acrylic paint dry before adding orange paint to the bodies of some of the fish. The treatment should be very stylized.

STEP 3

Add a third color, ultramarine blue, forming a very transparent glaze on the reflections of the water with it. Then use thicker paint to paint the fish in the center. Again, reduce the intensity of the color by going over it with a damp roller.

STEP 4

The paraffin should be applied at the end of the exercise, when the acrylic paint has completely dried and formed a whitish glaze that blurs the shapes. Spread it with a flat metal spatula.

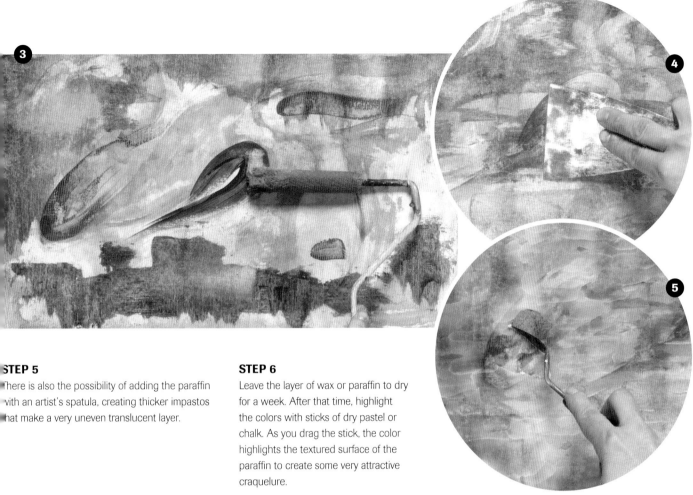

STEP 5

There is also the possibility of adding the paraffin with an artist's spatula, creating thicker impastos that make a very uneven translucent layer.

STEP 6

Leave the layer of wax or paraffin to dry for a week. After that time, highlight the colors with sticks of dry pastel or chalk. As you drag the stick, the color highlights the textured surface of the paraffin to create some very attractive craquelure.

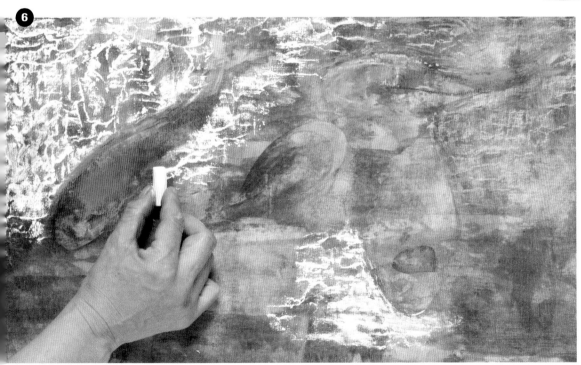

STEP 7

When painting with wax crayons, your fingers can be a big help in rubbing and blending the colors and reducing the effects of the texture. The final step consists of fixing the pastels to the support with aerosol spray varnish fixative.

STEP 8

You must wait a few hours for the layer of varnish to dry, and only after this can you proceed to spread a new layer of paraffin. This time, mix it with a small amount of white oil paint, making sure that the layer of wax is thinner over the fish and a bit thicker on the water.

FINAL STATE

In the finished image, you can see that the fish have been turned into formless masses of color, with blurred and imprecise edges. They emerge from a layer of whitish wax that is worn, with bare spots and impastos—a very attractive textured finish.

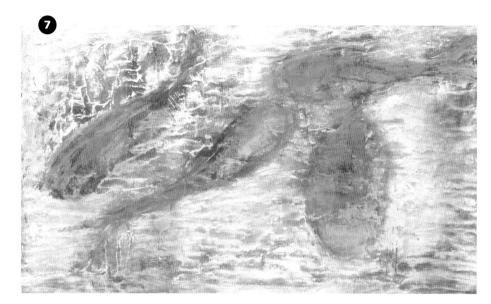

Another color interpretation created with acrylics

STEP 1

Here is another option. First, cover the surface of the support with a layer of beige acrylic, and then paint the carp over it with vivid colors, using long and rhythmic brushstrokes.

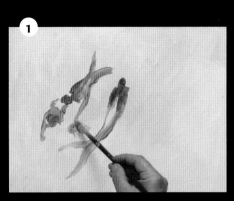

STEP 2

The resolution of the carp, despite being very painterly and based on the contrast of bright orange and blue colors, is very stylized and should depict the fish in very few strokes. Allow the paint to dry well before applying the paraffin.

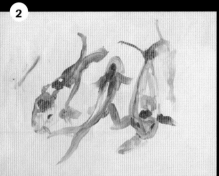

STEP 3

Mix the paraffin on the palette with a little bit of white oil paint. Apply it thickly on the support, making a layer of white that nearly completely covers the model.

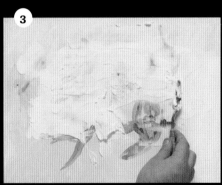
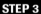

STEP 4

With the artist's metal spatula, carefully scrape away the fresh layer of wax until the shapes of the fish begin to faintly appear. They should be suggested underneath a layer of white glaze.

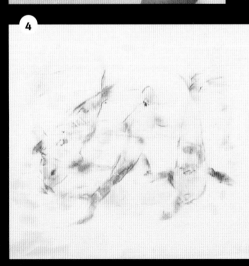

WORKING METHODS

We cannot end this book without offering the reader different strategies for optimizing experimentation in this complicated world of abstraction. Planning the work well is always a guarantee of good results. For this reason, it is important to be aware of some approaches to exploring forms, playing with color, and making the most of the painting media that you are using. All of this is done with the goal of creating studies and small-format works, a collection of experiments that might well be the jumping off place for creations of much larger format.

WORKING METHODS

The Search for a Personal Repertoire

The most important aspect of abstract painting is experimentation, trying different interpretations. You do not have to become obsessed with finding a personal style; if you work persistently, it will end up appearing almost spontaneously. There are different ways of planning the work. For example, you can make sketches in notebooks and practice various compositions and colors in small-format works. The goal of these first steps is to try things, discovering the effectiveness and the impact of a preliminary idea.

The preliminary attempts do not necessarily have to make a good impression at first. Many times they might even be failures. The advantage of all this is that the paintings that do not look good can be allowed to dry and painted over later. Even then, a failed work can be converted into something ingenious and surprising.

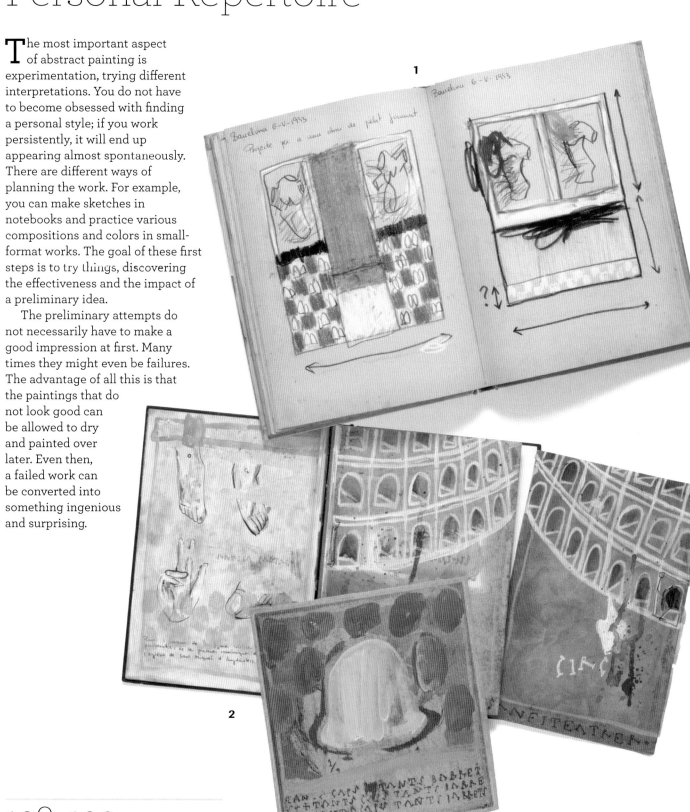

1

2

3

Artists carry out all kinds of strategies in their desire to develop a personal and unique style. One of the most common is making small-format works, which allows them to obtain results very quickly, imprinting speed and energy in the execution, and doing it while using few colors. Small-format works can be compared to laboratory test tubes: if the formula works in a small size, then there is always the possibility of being able to create a more definitive work in a larger size.

1 The first ideas, the initial sketches of an abstract painting should be made in a notebook or sketchbook. Just a few drawing tools and a few wax crayons will be enough to draw schematic shapes that illustrate an idea and sketch out a composition with a rough distribution of colors.

2 After sketching a preliminary idea in the notebook, it should be developed. Begin by studying small color studies that can be made in the sketchbook. It is best to use acrylic paint instead of oils because of its quick drying time.

3 There are other ways of developing ideas that do not fit in with traditional media and techniques. One of them is working on acetate with black synthetic paint. Draw shapes or patterns on the acetate that can later be superimposed or combined with different background colors. This material allows you to see how a graphic would work by simply laying it over a canvas rather than having to paint on it.

Planning Work Based on a Series

A good way to make progress in painting abstracts is to work based on a series; that is, return to certain practices and even repeat works with the goal of exploiting all the interpretive and expressive possibilities. We advise choosing a single model, which could be a photograph, and attempting to discover different interpretations by varying the colors, the technique, and the way you apply the paint with the brush, and then observing how these variations effect and reverberate in the final result.

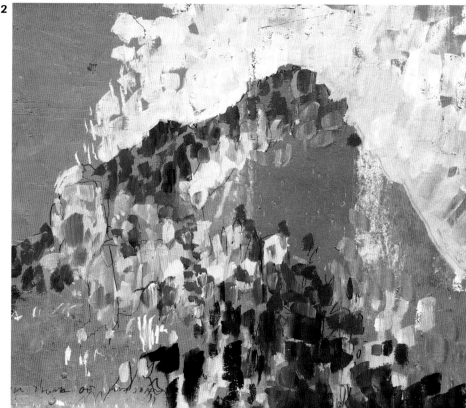

A Single Theme, Different Interpretations

A group of canoes serve as the inspiration for these variations on a theme. In the first painting, the forms are synthesized with decisive and clear brushstrokes, which contrast with the second painting made with sgrafitto lines made in a thick fresh coat of paint. The next version was created by dragging green paint with a flat spatula and painting only the space surrounding the boats with white. The last one was done with dry color pastel lines drawn on a layer of varnish poured over a dark background.

1 To achieve different results, it is enough to vary the materials that you use for painting. In this work made on Japanese mulberry paper, we used a fan-shaped brush This brush creates open and diaphanous strokes that leave a trail of very interesting fine streaks.

2 On a recycled support covered with a layer of pink oil paint, we painted a rather incomplete mountain, letting parts of the background show through. We worked with small strokes made with a flat brush and very thick oil paint.

3 The focus of this work is completely different from the previous one. It is based on a reddish background that is covered with long overlaid brushstrokes that streak some of the still wet underlying paint. The strokes fill the entire surface of the painting, although they allow the background to show through.

Planning Work Based on a Series

Learning from Chance and Deconstruction

The unpredictable nature of diluted paint can turn it into an interesting medium for artists who wish to experiment with abstraction. Mixing paints with different viscosities on a horizontal support creates interesting shapes, transitions of colors that evoke poetic forms, and explosions of fluids that expand to create capricious colors that escape from the artist's control. Chance, therefore, is our ally. Following are some examples.

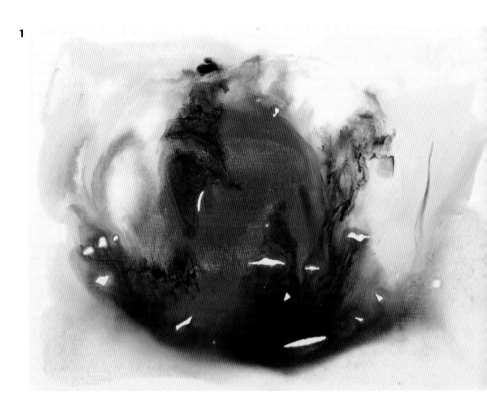

1

Encouraging Chance

Working with fluids adds a strong component of chance to your work. Far from being an inconvenience, this can become an interesting field of study in how to achieve highly attractive artistic effects. To put this into practice, prepare several supports and lay them flat on a table. In a separate area, dilute three oil colors with turpentine in some small containers: Naples yellow, cadmium red, and ivory black. The paint should be very liquid. Take a container of retouching varnish for oils, and pour it over each one of the supports. Next, incorporate some drips from each one of the colors on the varnish so that you only have to wait for the colors to mix randomly. No matter how many times you repeat these steps, the colors will never mix in the same way.

1 Pour a capful of varnish on a flat support, and then apply yellow, red, and black liquid oil paint with turpentine. Leave them for a few minutes so the colors can flow and overlay to create interesting shapes that are reminiscent of columns of smoke, aquatic plants, etc.

2 Apply the paint in a similar manner as before, but this time pour some drops of acrylic ink over the layer of varnish and oils. Since oil and water do not mix, this will cause the acrylic paint to condense into drops, rounded isolated shapes that are repelled by the underlying base colors.

3 Here apply acrylic ink on the red, black, and yellow oil and varnish base. Hold the support in your hands and make circular movements with it. Then both media—the acrylic and the oil—will mix, generating some very interesting splotches.

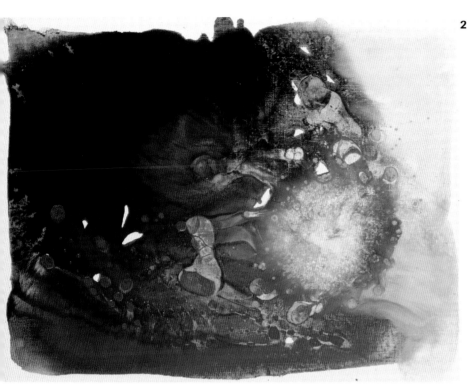

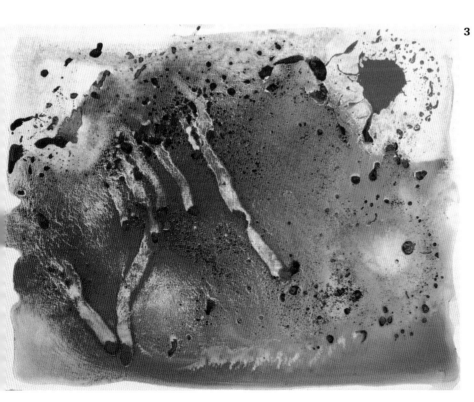

Constructions Made with Scraps

This exercise in deconstruction consists of cutting up some color studies or paintings that are not to your liking and assembling them to construct a new and much more intriguing work. It is a very effective creative process that trains artists in choosing and combining shapes. This way they will have greater control over the creative work, and the resulting abstract work will be the fruit of a simple but very profound reflexive process. Cut out the parts with the colors that attract your interest and start arranging them until you find a satisfactory combination; then, glue the cutouts to a rigid support with white glue.

2

3

Learning from Chance and Deconstruction

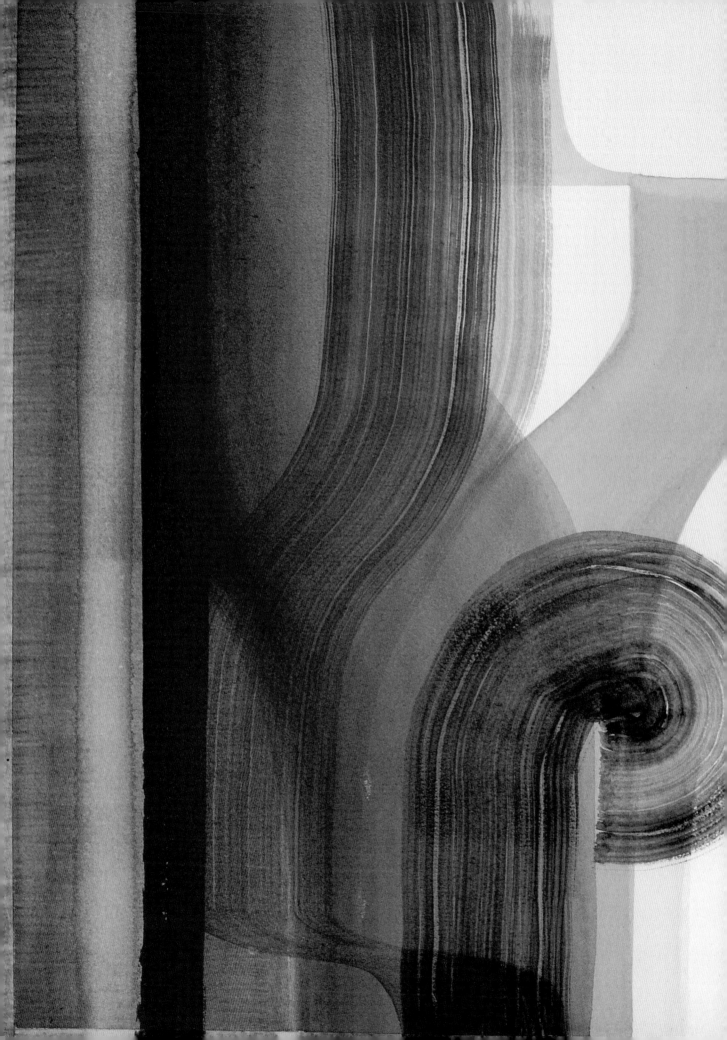